Re Questrian

Who has not loved horses?

Who has not been terrified by horses?

Who has not been drawn by horses?

Who has not been . . . ridden . . . petted . . . been thrown . . .

By horses?

Never?

Not even in dreams?

Not ever way back . . . almost before you

Remember . . . you never took a pencil . . .

Or rode a stick and imagined?

You never . . . being so small . . . were ever

Swung up faster than an elevator leaves

Your stomach . . . to find yourself sitting . . .

On the living warm powerful fur skin

Bones and mind . . . finally ready to go anywhere.

You never ached or cried over . . .

Black Beauty . . . The Finish Line . . . Manowar . . . Flicka?

I don't believe it. You're lying.

Look at Debbie's horses. You'll remember.

WILLIAM T. WILEY

AUGUST 1981

P.S. These are not horses.

ART MUSEUM OF SOUTH TEXAS

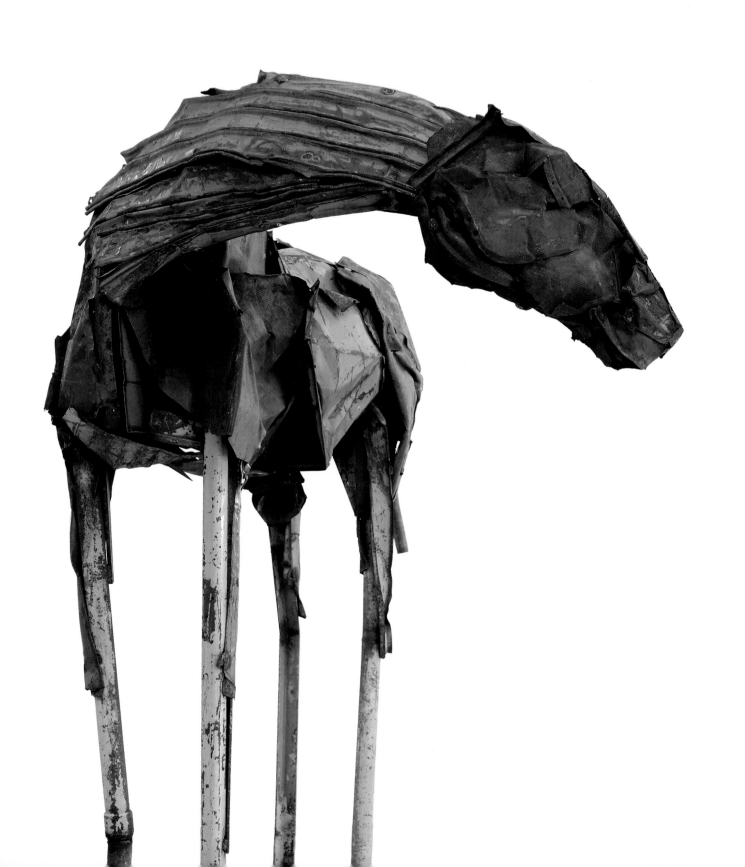

HORSES

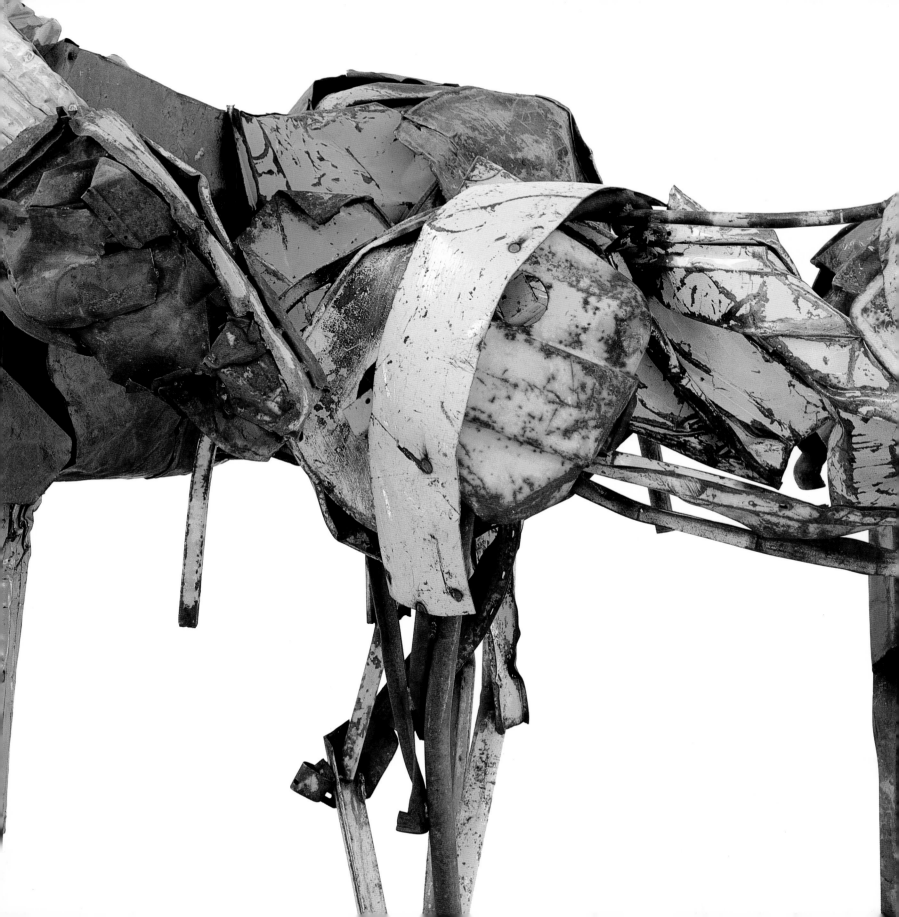

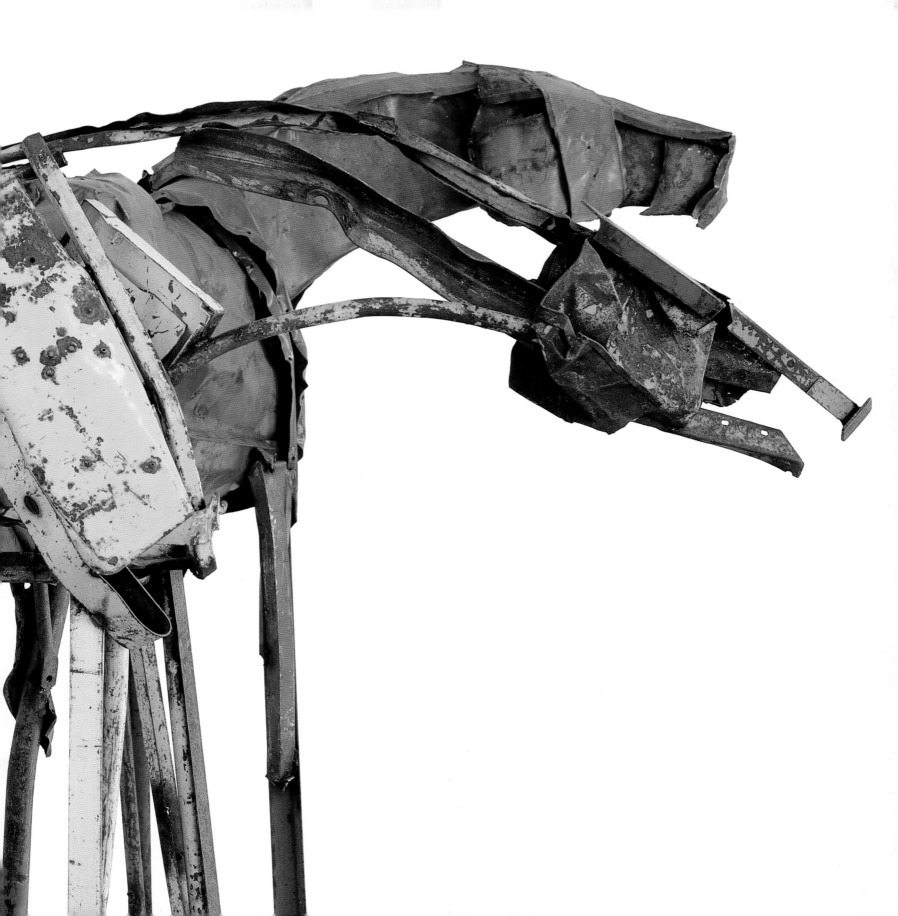

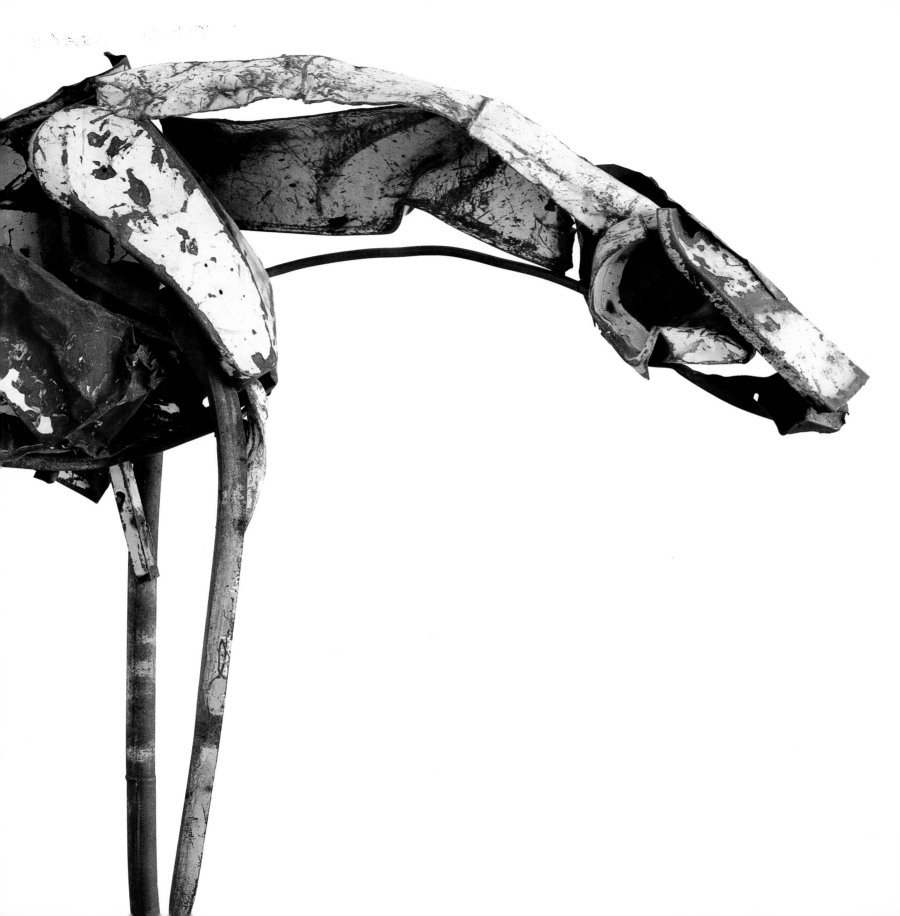

HORSES

THE ART OF DEBORAH BUTTERFIELD

ESSAY BY DONALD KUSPIT

INTERVIEW BY MARCIA TUCKER

LOWE ART MUSEUM

UNIVERSITY OF MIAMI

CORAL GABLES, FLORIDA

CHRONICLE BOOKS

SAN FRANCISCO

Published by the Lowe Art Museum and Chronicle Books on the occasion of the exhibition *Horses: The Art of Deborah Butterfield*, February 6–March 29, 1992, Lowe Art Museum, University of Miami, Coral Gables, Florida.

The works of art are reproduced with permission of the artist. The poem by William T. Wiley is printed with permission of the author. Marcia Tucker's interview with Deborah Butterfield appeared in a slightly different version in *Art in America*, vol. 77, no. 6 (June 1989). Reprinted with the permission of the author and *Art in America*.

The research and publication of this catalogue has been made possible in part by a grant from the National Endowment for the Arts, a federal agency.

The University of Miami/Lowe Art Museum is recognized by the State of Florida as a Major Cultural Institution and receives major funding from the State of Florida through the Florida Department of State, the Florida Arts Council, and the Division of Cultural Affairs, with the additional support of the Metropolitan Dade County Cultural Affairs Council and the Metropolitan Dade County Board of County Commissioners.

Cover: *Ferdinand*, 1990 (p. 50), and *Palma*, 1990 (p. 42)
Back cover: *Untitled (Horse)*, 1981 (p. 27)
Photographs of Deborah Butterfield on pp. 84, 96 © R. Milon; p. 86 by Rob Outlaw; back flap by Images Photography, Kona, Hawaii.

Edited and designed by Marquand Books, Inc., Seattle
Designed by Scott Hudson
Typography by The Type Gallery, Inc., Seattle
Printed and bound in Hong Kong by Dai Nippon Printing Co., Ltd.

Library of Congress Cataloging-in-Publication Data
Butterfield, Deborah, 1949–
 Horses : the art of Deborah Butterfield / essay by Donald Kuspit : interview by Marcia Tucker. p. cm.
 Includes bibliographical references.
 ISBN 0–8118–0137–3 (hard) : $29.95 — ISBN 0–8118–0138–1 (soft) : $19.95
 1. Butterfield, Deborah, 1949– —Exhibitions. 2. Horses in art—Exhibitions. I. Kuspit, Donald B. (Donald Burton), 1935–II. Tucker, Marcia. III. Lowe Art Museum. IV. Title.
NB237.B87A4 1992
730′.92—dc20 91-31124

Distributed in Canada by Raincoast Books
112 East Third Avenue, Vancouver, B.C. V5T 1C8

10 9 8 7 6 5 4 3 2 1

Chronicle Books
275 Fifth Street
San Francisco, California 94103

IN

MEMORY

OF ISMANI

CONTENTS

ACKNOWLEDGMENTS

Deborah Butterfield's lyrical obsession with equine imagery continues. Through a continuum of changing shape, scale, medium, and style her singular vision remains as compelling as it is moving, as contemporary as it is primitive. The great and immediate power we experience when in the presence of her heroic forms attests to a natural and sympathetic collaboration of spirit.

But while Butterfield's sculpture has long enjoyed popular appeal and critical acclaim, exhibitions of her work have not been accompanied by significant documentation. The Lowe Art Museum is pleased that in conceiving *Horses*, it has, so to speak, acted as midwife for the first full-fledged catalogue to enhance awareness and understanding of Butterfield's work.

Donald Kuspit's essay and Marcia Tucker's interview offer alternate approaches to the elucidation of art and artist. And there is something to be said—at long last—for a handsome format that encourages further perusal, contemplation, and consideration of Butterfield's beguiling creatures long after the experience of the gallery subsides.

My thanks to Roberta Lieberman for her encouragement and artful mediation; to Deborah Butterfield for her advice and assistance; to Lowe Art Museum director Brian Dursum for giving me free rein to pursue this project and joining my enthusiasm with his own; and to registrar José Guitian for orchestrating the elaborate transportation logistics for the exhibition. Finally, I am most indebted to those public and private collectors whose artistic sensibilities and generosity determined this endeavor.

DENISE GERSON
CURATOR OF EXHIBITIONS
LOWE ART MUSEUM

UNTITLED

(DRY FORK SERIES)

(detail)

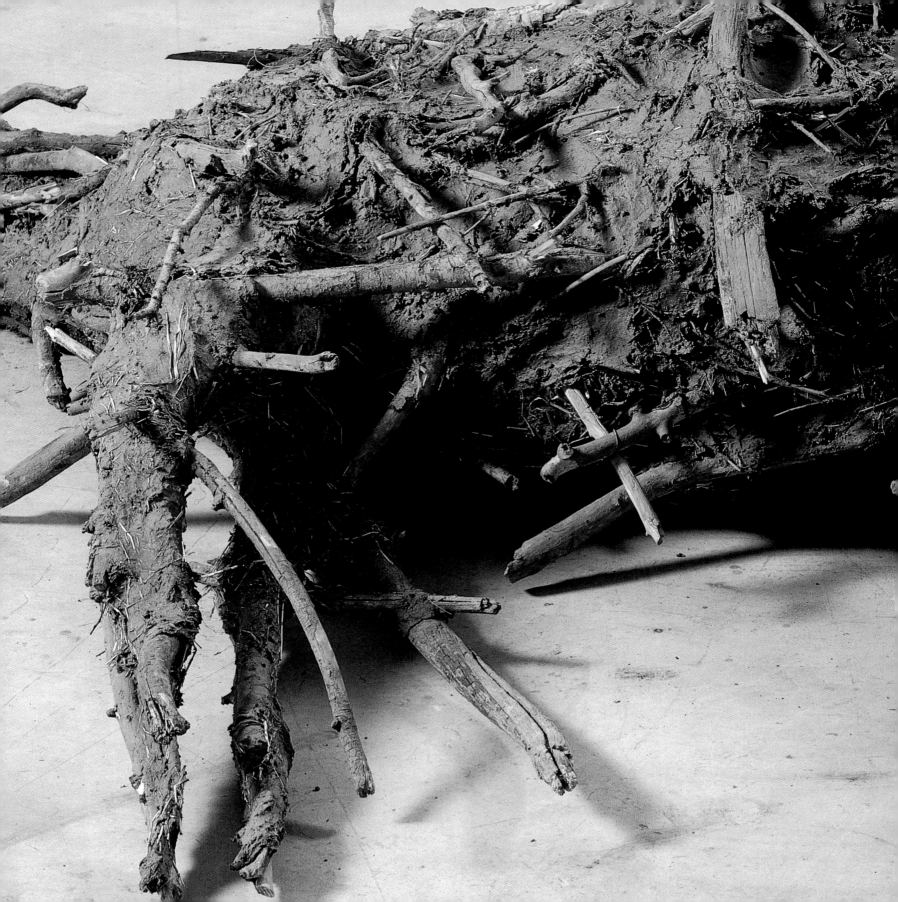

AN INTERVIEW WITH

DEBORAH BUTTERFIELD

MARCIA TUCKER

BOZEMAN, MONTANA

JULY 1988

WHISTLEJACKET

(detail)

MT: What do you feel is the most important issue for you as an artist right now?

DB: I suppose I feel that what's most important is to try to make work that advances you as a human being, that somehow pushes you to keep asking yourself questions, makes other people ask questions, and hopefully encourages them to see the world through different eyes. When I was a little kid I wanted to be able to be inside somebody else's body and see through their eyes for just a minute. I felt that if I could do that I could understand myself and the world so much better.

And I guess that's what art is about. If you're a musician or a writer, in a way it's easier to do that because the work is more literal, or in the case of music, more physical. And I suppose that's why I make sculpture, because I feel that people have to sense my work almost as much with their skin as with their eyes, and in doing so they learn a different way of perceiving the

world. If we could each just learn to step into the other for a while, we'd be a lot better off.

Art is very important in terms of politics; not just in a literal way, meaning that we should all do work that's overtly political, but in the sense that we have to make that step of transference into someone's otherness.

RIOT

(detail)

MT: I'm curious as to whether you think that this is also a major issue for other artists today? To make work which, as you describe it, advances you as a human being?

DB: Well, I certainly hope so. I know it's true of most of the artists that I know; those whose work I admire. I have a sense that for a lot of wonderful artists—Jackie Windsor, Martin Puryear, William Wiley, John Buck, Roy De Forest, Terry Allen, to name just a few—the art is almost like the debris left over from the process of thinking and growing. It's almost like a snakeskin that's been shed and left behind.

MT: Are you talking basically about a process of empathy?

DB: I guess that's one of the things. Everyone has different problems to solve in their lives, and I think that empathy would be one of them. For me, it's really what my work is about, because I not only want people to see the world through my eyes, but I also want to try to talk about language with another species, which happens to be the horse, and perhaps to gain more and different information by transferring or becoming empathetic to another creature.

But I don't know that all art has to do with empathy. We each have a set of problems that we're destined to deal with in our lives, whether someone's into art, or psychotherapy, or the bond market—I don't know. We all have these things to work through.

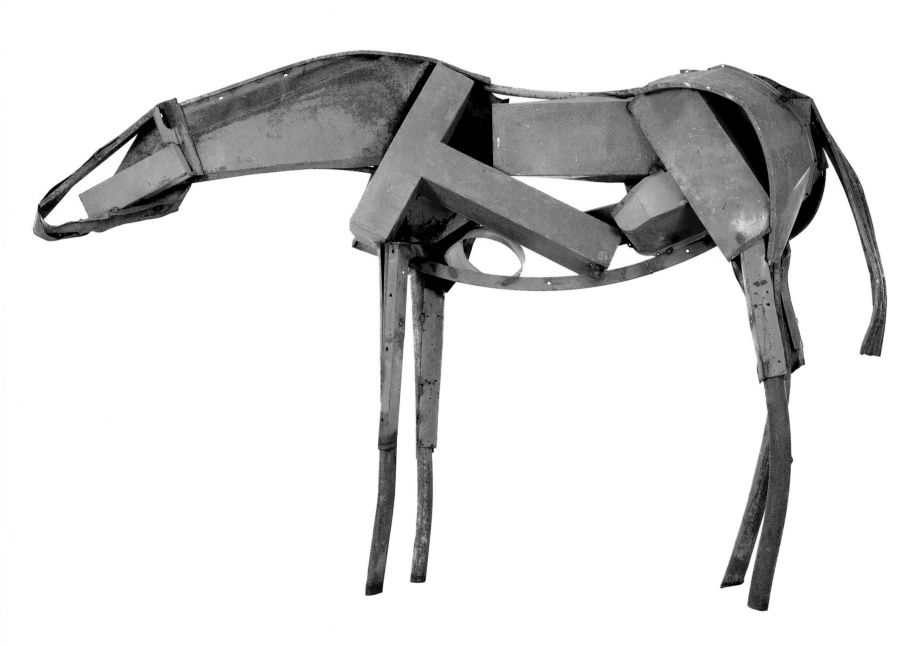

R I O T

1990

steel

MT: Do you think art is, or should be, political?

DB: I think it is, in a nonspecific way, inherently political, because to me the function of art is to make people think, and perhaps to make them think about things that they're not comfortable thinking about, or think in ways that they're not familiar with. There's other art that's more specifically political, whose actual form and content relates to events which we normally think of as being political.

MT: How do you feel about that kind of work?

DB: Some of my favorite work is political in this sense. In the early 1970s when I was still in graduate school, when we were still involved in the Vietnam War, I did a lot of political work, campaigning for candidates and knocking on doors and discussing the Vietnam War with people I didn't even know. And I found it a very frustrating and draining experience, and yet felt guilty being in my studio. William Wiley was one of my major teachers and influences at that time, and he was involved with the I Ching, and he used to say, "If you want to influence somebody, be like the sun at midday." Somehow it made me understand that perhaps I was not as good as some other people at being a political activist, and that probably the best thing for me was to do what I knew best how to do, which was making art; I didn't know how to do it very well, but it seemed that it was the only thing that I had any hope of doing halfway decently.

So it kind of resolved a conflict about staying in the studio and working. Also my work started out being political in a very subtle way; almost all the horse sculpture I had ever seen had to do with giant war horses, who were invariably stallions, carrying generals off to kill people.

You know, horses actually changed the history of the world. Up until World War I, the horse was basically used as a weapon. The horse conquered the world, and only now, in the twentieth century, do we think of the horse

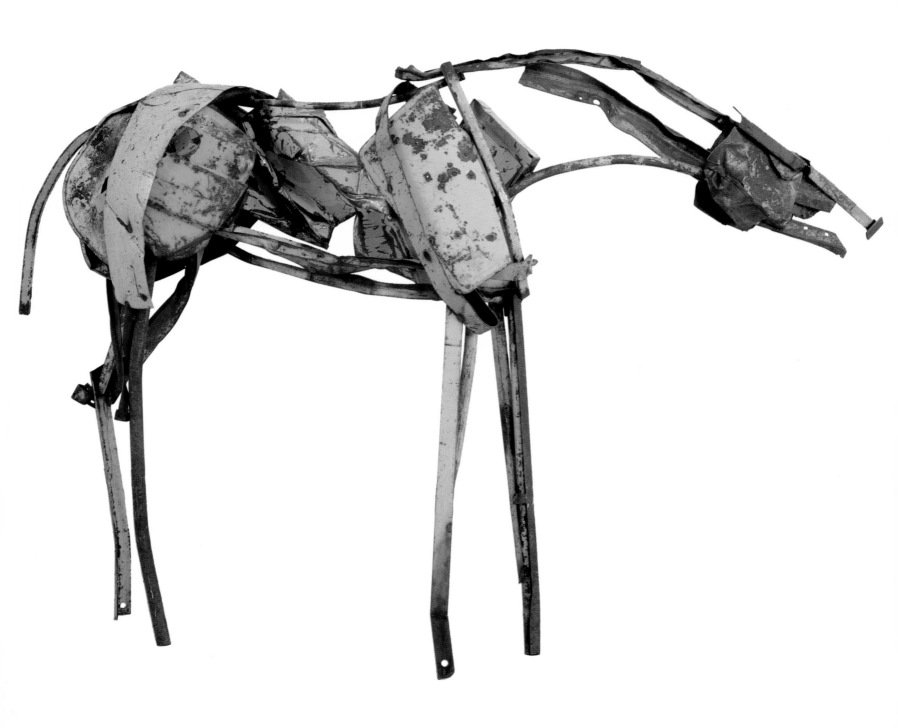

for sport, for pleasure, or for art. It was basically a way of exercising power over people who didn't have it.

So instead I wanted to make a sculpture of a mare expecting a baby. I had the naive assumption at the time that if women were in control of government we wouldn't be in a war. Now I think I'm not so optimistic about that, but I really did feel that it was true at that time. And so in my own quiet way, I was making art that was against war. And it was about the issues of procreation and nurturing rather than destruction and demolition.

MT: Do you think that making art is, in fact, different from other kinds of work or from other kinds of creative endeavor?

DB: Yes, I think it is. Probably the end result is the same. But I think that people who end up making art learn differently than other people do. We obviously learn visually but it's also a kinetic thing; you learn by doing. For example, I can't sit down and think of an idea that I want to do. I can sort of get a general feeling, but it's hardly a verbal idea. I don't know what it is I'm doing until I'm in my studio moving around, being fairly uncomfortable, sweating and working, and then as I do things I react to them. I suppose it would be almost an Abstract Expressionist way of working; I act, and I react to that action. I add and I subtract. A lot of people learn by hearing, or by logic — people have very different ways of thinking, and that's what's so interesting about all the different art forms.

For example, a mathematician told me about another young mathematician, Michael F. Atiyah, who envisioned a whole new form of mathematics, and he didn't work it out with numbers but saw it in his mind complete, like a movie. Then he went back and worked out the numerical stuff, but first he saw it. So it isn't only artists who see things in their minds. Nonetheless, I think different people learn different things in different ways. For instance when I was in high school they had a new way of learning languages — you

WHISTLEJACKET

1988

steel

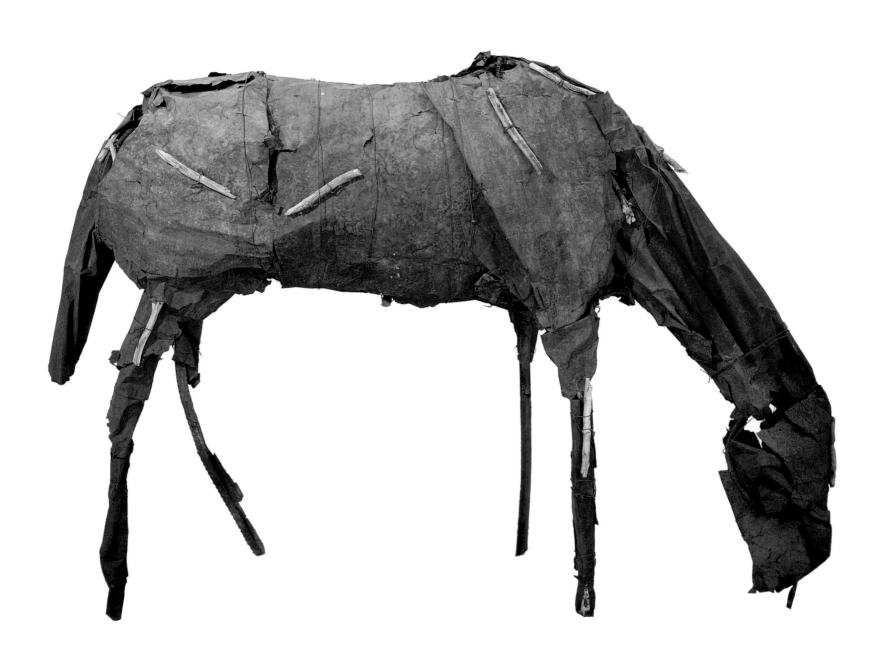

weren't allowed to look at the words, just to hear them on tapes. Well, my grades in language went down ridiculously, because I'm a visual person, and I couldn't separate the words when I heard them on the tape; one word ran into the next, but once I could see the words written out I could understand it.

MT: But do you think that artists are special or different from other people?

DB: No, I guess I think that we're just people who have figured out a way of learning or doing things that's more direct and more directly rewarding than perhaps a lot of other fields.

MT: More rewarding to you, you mean?

DB: More rewarding to the artist, and hopefully to the viewer.

MT: But aren't most people put off by contemporary art? Aren't they mostly extremely baffled and threatened by most work, and feel that it's not accessible to them at all?

CHESTNUT

1981

steel, wood

DB: Well, I was just at Ed Kienholz's place [in Hope, Idaho] and people from the community were talking to me about my work, and it was pretty exciting. I imagine it has as much to do with the context in which the work was presented as the work itself. I also feel that with my work—and I always hope it's not too "soft"—a horse is something that's more accessible to many people than other forms of art are, and I can't delude myself about that. I certainly hope that my work has something for people who are much more advanced in terms of contemporary art, but I know that it also offers something to ten-year-old girls. (Laughter)

D.B. 10-78-V

(RECLINING HORSE)

1978

mud, sticks, straw, steel

MT: Speaking of girls—do you think being a woman actually makes a difference in how a work is made and how it's perceived?

DB: Well, I think that it really does matter in the making of the work. I don't necessarily know about how it's perceived, because a lot of my favorite women artists' work is nonobjective, and I don't know if you'd actually know that a woman made it. But often I find myself admiring work and then being sort of smugly and happily surprised to find out that it was made by a woman. I find myself saying, "Oh, no wonder!" So I guess I do have that feeling. Although most of my teachers at Davis were men, I feel that most of their work was very "female"—William Wiley and Roy De Forest, for instance; I feel that their work was very whole, that they were very realized in terms of both sides of their nature.

I don't know that you need to be a woman to do feminist work, or female work. But in terms of making work, who you are determines the kind of work that you make. And I'm sure that being male is different than being female. Your body is different. I know I make different work when I'm pregnant or nursing a baby than I do when I'm not. I'm a different person!

MT: Don't you think that there are more than two sides to one's nature, that one's nature has many sides? The problem is that gender is defined outside of ourselves. We're brought up into a gendered world, a world which has already defined us.

For example, you may not want to be seen as a "woman sculptor," but as soon as the world finds out that you're a woman, they perceive your work in a certain way. I wonder if it's possible for people to perceive anything neutrally in a world which is not neutral.

DB: Well, I think we think we're perceiving it neutrally when we're not. We all like to have the fantasy that we are. I don't really mind at all being a woman who makes sculpture; I particularly enjoy it. But being a "woman

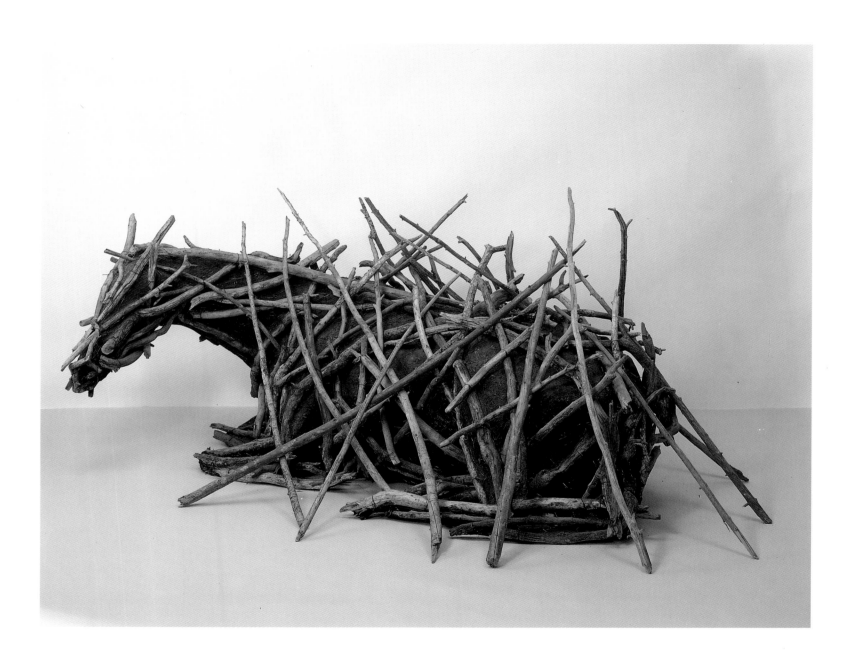

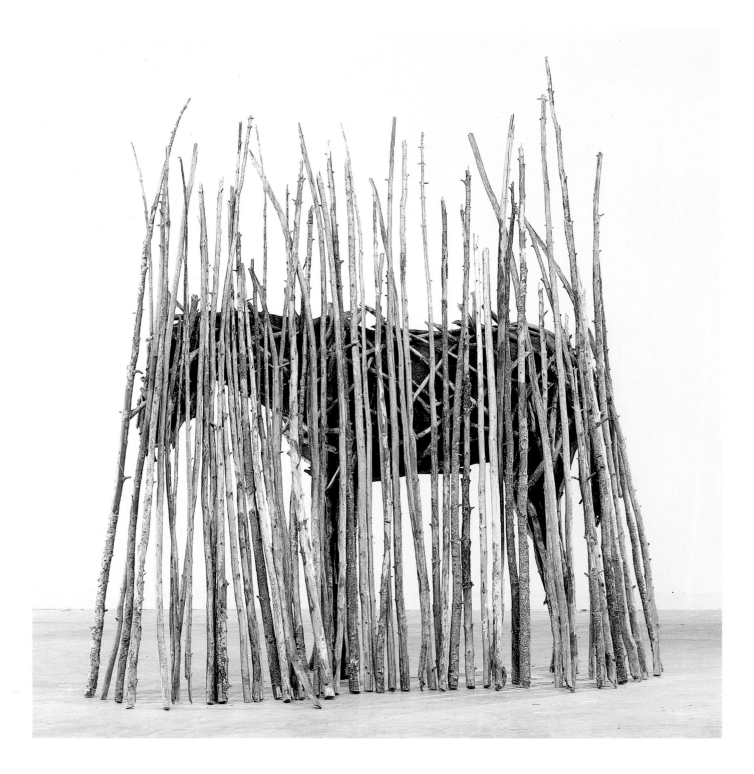

U N T I T L E D (H O R S E N O . 6)

1978

mud, sticks, steel

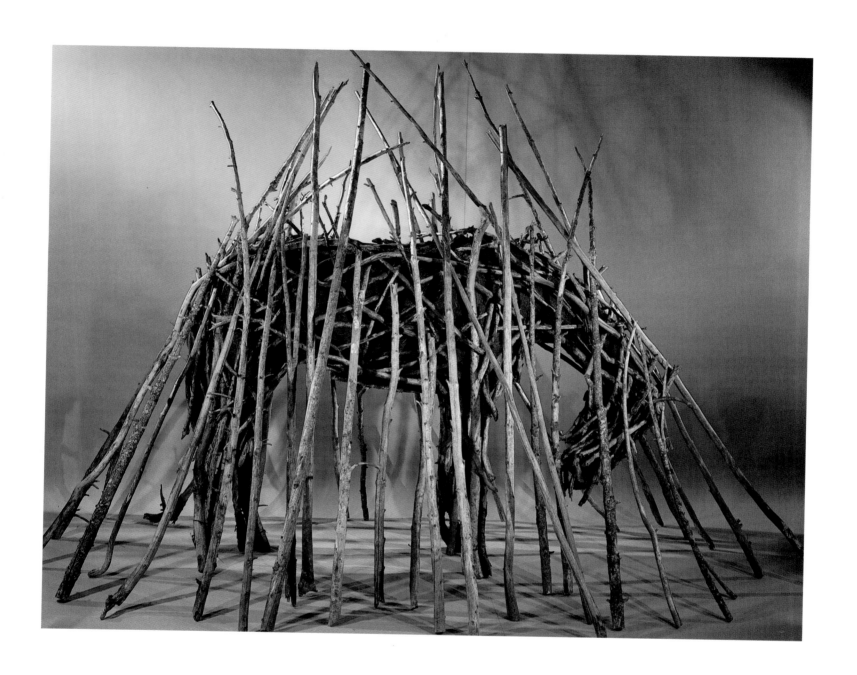

UNTITLED (HORSE NO. 7)

1978

mud, sticks, steel

sculptor'' could be like being a black baseball player, or a short museum director. We hope that way of thinking isn't the norm, but surely it is.

MT: I know that in the early 1970s, as a feminist, I felt that "the personal was the political." I don't feel that any longer; now I feel that it has to be more than personal. I feel that my own political activism, now that I'm older, has to do with having a voice, a voice that people might hear.

DB: Yes. I suppose you have to speak from the general to the specific, whereas as an artist I feel I have to speak from the specific, because it's the only thing I know. I mean, I send money to the general, but I work from the specific. It's like being a teacher, and having young sculpture students say, "I can't think of anything original, everything's been done." I tell them that if they make a cube out of cardboard they're going to make it differently than the person sitting next to them, and that's the place to start. You have to trust yourself because the way you chew gum is going to be different than the guy next to you. You just have to start from somewhere; you have to trust in yourself to carry through with that kind of quality, or that peculiar vision that's your own. I feel that the specific is very important. It helps us to understand and be empathetic to the general.

Also, living in Montana, and growing up in the West, is so different from growing up in the East, particularly the class systems, both in terms of economics and gender. I mean, this is the land of Annie Oakley, after all! There's a cultural tradition out here of women being rough and tough and independent and strong. And none of the ranchers or farmers could ever have made it without their wives working beside them. So I do think we have a different cultural set than people in the East do, where the tradition from Europe is much stronger and more pervasive.

UNTITLED

(HORSE)

1981

paper, sticks, wire

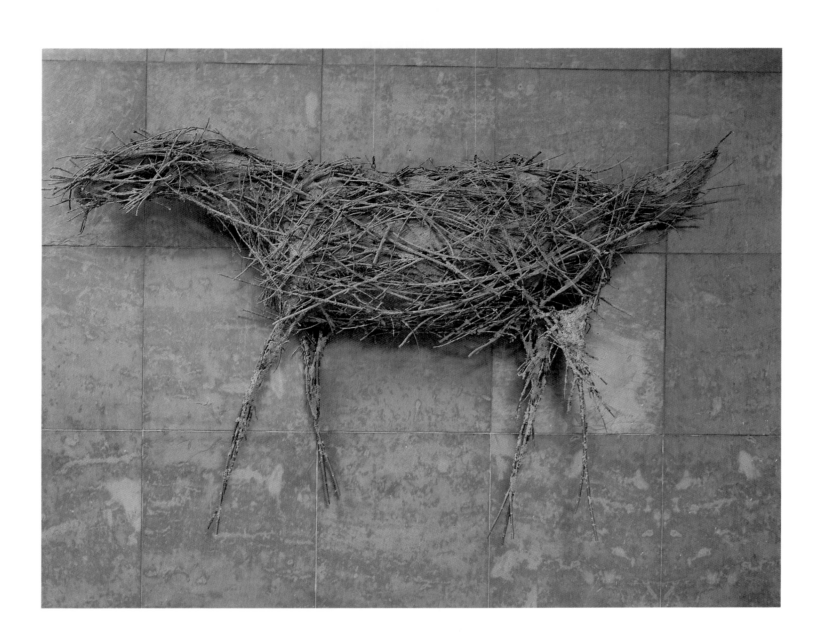

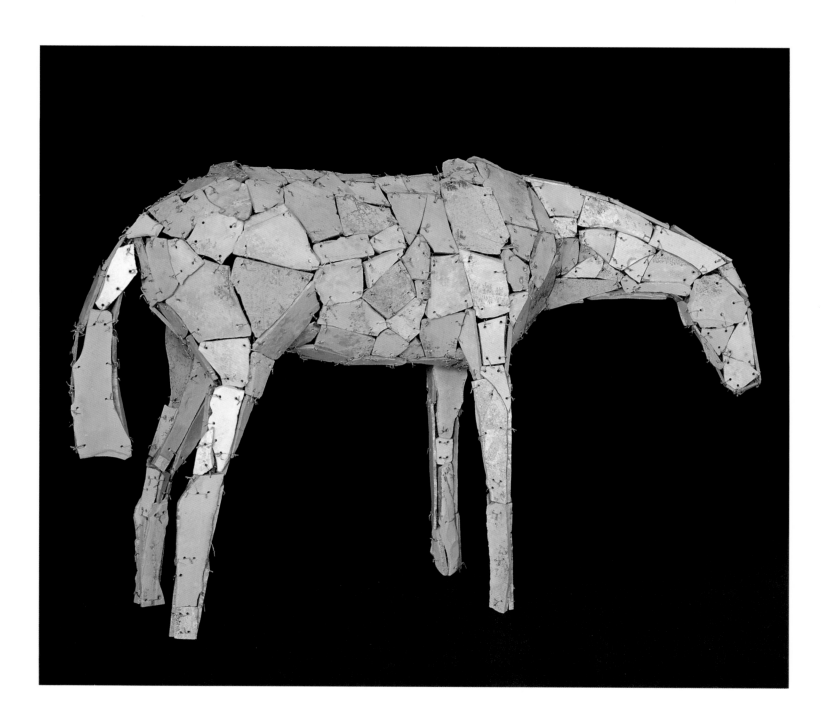

MT: Speaking of the East, how do you think the art world has changed in recent years?

DB: I guess that I would have to say that I feel there's a real polarity going on right now . . . one edge is totally economic, and the other edge seems to be totally spiritual.

It also seems that there's a lot more money in it now, at least that's my perception. I certainly am able to make money from my work now, and a lot of other people I know are; it's been very helpful to really make a living. Being successful means being able to do what I do more easily, with greater joy.

MT: Do you think there's anything bad about being successful?

DB: I think many of us are unprepared for success. I feel as if somehow you've got to pay. I find myself maybe making less work, because I know that the work will sell, and I question my sincerity in making it. It's frightening. A few years ago I almost became paralyzed, unable to work, because I knew that I would get money for what I did, and it made me feel guilty. I don't know how one resolves that; after a while, though, you just get so you want to make work again. And you start making it.

MT: That makes a lot of sense to me. There's a truism that women fear success rather than failure; I think it has a lot to do with our backgrounds, how we were raised, what the expectations were. But this also has to do with taking risks in general: do you think that's important in making art? What does taking a risk mean to you?

DB: God, I think just going into the studio, for one, is pretty risky!

MT: What's your worst fear?

DB: Not doing something as good as I did before. For me, I never feel as if

H A N H O R S E

1985

steel, copper, wire, slate

I'll ever do something as good as something I've already done. Getting started is enormously difficult for me. I know a lot of people think, "Oh, she just makes horses, so what is so scary about getting started?" In a way it's worse, because the fear of repetition is greater, and the challenge of being new, and going deeper. I guess I'm sort of married to the horse at this point. I could find a new boyfriend or I could get more serious about what I've got.

The horses are important to me on many levels. Real horses are important to me, so in many ways my art is so much about real horses, and in other ways it's not about them at all. And so I'm always afraid I won't find anything new, which doesn't have so much to do with the product as finding out one's religion is hollow or something.

At one point I thought I was going to be a potter for the rest of my life. It was a spiritually fulfilling thing for me, and one day it just came up empty. And it was very frightening to lose one's faith, so to speak. That's when I finally bit the bullet and faced the fact that horses are what I am truly interested in, and have been since I was old enough to think, even before I could talk. And the fear that I'll come up dry in my belief is probably the most frightening thing.

MT: Do you think that's a fear for everyone, or for most artists?
DB: I think so. It's about faith, at one level, faith in your ability to connect with something. It's like a chemical reaction; it seems as if it's holy to have a conversation. To me, that's what being alive is about. It's about a conversation or a dialogue, and you just hope that you'll be able to come up with a new question. I think maybe that coming up with a new question is much scarier than being able to answer. The question almost determines the answer.

MT: For me also, every time I begin to work, I have to ask myself why I'm doing this. And I also have the same fear, that I'll never be able to write

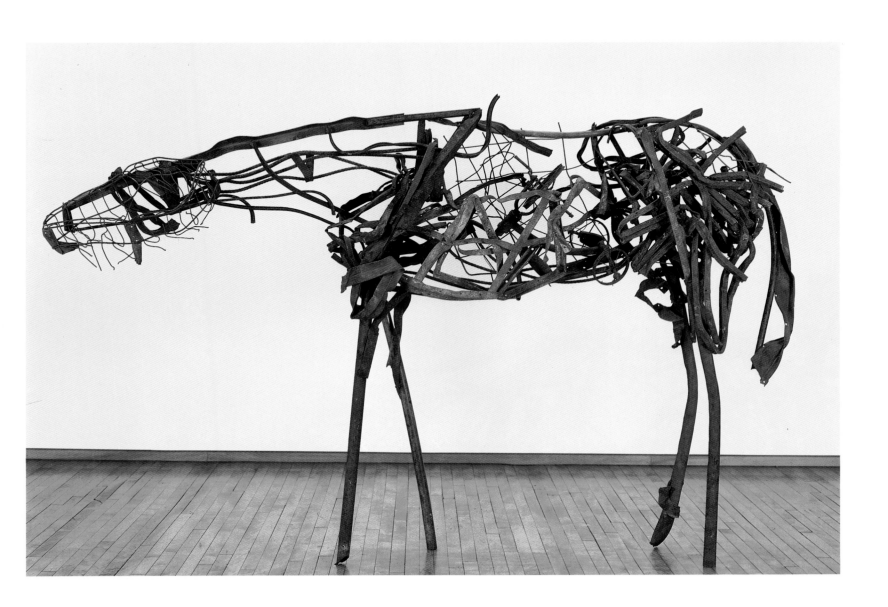

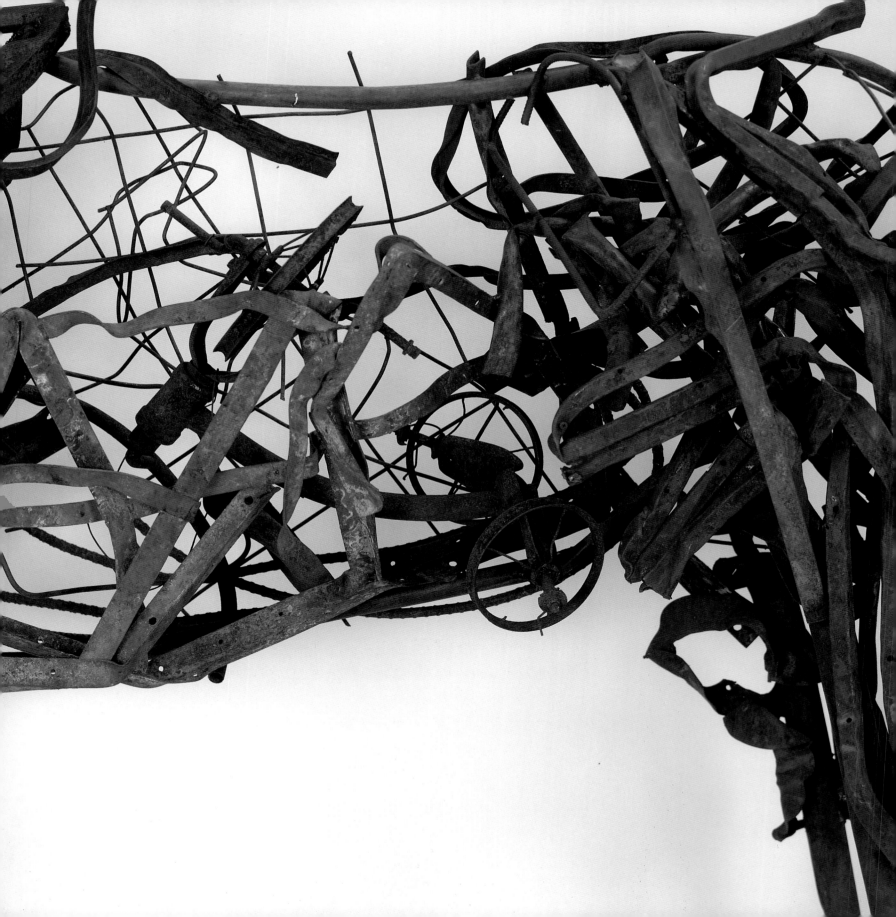

anything again. And of course, not everything one makes can be as good as the one before.

DB: Right. It's hard to accept the fact that you may actually fail. And it's even harder not to totally condemn yourself for that. I guess that's what I was saying. When you're pregnant or when you're nursing a baby you're different from when you're not, and maybe physically you're going to have less stamina or less strength, or you're going to be more — what's the word? — sappy. So sometimes I make work that's perhaps verging on the sentimental, but if everything I made were really tough, that would have no meaning; you have to allow yourself to be who you are at that moment, because without sappy, tough doesn't mean anything. I think making something sappy at this point is a whole lot riskier than making something really tough.

MT: What makes a good piece?

DB: I don't know. I'm afraid to know. If you can figure it out then you probably have a formula. I think total engagement, and not taking the easy way out. There are certain solutions that will give you a successful piece, and I try to only use those if I'm really desperate. (Laughter) I'm not above using them, either. I'll do anything to come out okay, but generally I try to stay honest.

MT: There must have been, in the past, some difficult moments when you weren't sure how you could continue to make art. What sustained you?

DB: Oh, God. Boredom. (Laughter) Well, if I'm not making my work, I get mean and nasty and bored. To the point where I'm paralyzed, and I know I either have to go and ride a horse or go into the studio. And so I just keep working. That's what sustains me, and I've been really fortunate to have had enough success from the very beginning, to have had deadlines.

HOOVER

1984

steel, wood

MT: From the start?

DB: Pretty much. I feel so fortunate. I just sort of lucked into a reinforcement system. And having deadlines — I whine and crank about them, but basically I love deadlines, I love working under time and pressure. And having them kind of keeps me on an even keel. I probably love having something to complain about! But basically I feel that the content of my work has as much to do with the time limitations placed on it as with the subject matter. That time determines the form as much as anything else. It has to do partly with adrenaline and partly not, and partly with making myself into a sort of state of frenzy and calm. I guess some people do this by jumping off mountains and stuff. For me, it's working in the studio.

MT: And do you think that same thing would sustain you in the future?

DB: I certainly hope so! You know, there has to be a time when people are going to be tired of looking at horses, and it's very likely that I still won't be tired of making them. (Laughter) So I'll be like this old lady with a hundred cats. I think that I've sustained myself with the horse image because of my actual engagement with learning and training horses and being trained by horses. Every one is different. It's like dancing with a new partner. I don't think I'll ever get tired of dancing, you know. I hope I'll be able to dance until I die.

MT: But the horse is more than a horse for you; that's what you were saying before.

DB: Of course. I think real horses are more than real horses, too. For me, my involvement with them is in the formal discipline of dressage. I'm still at a very low level in this discipline, but it has to do with basically engaging in a dialogue with another species, where you both have to learn an intermediate language, which is very kinesthetic and very physical; it's like learning to

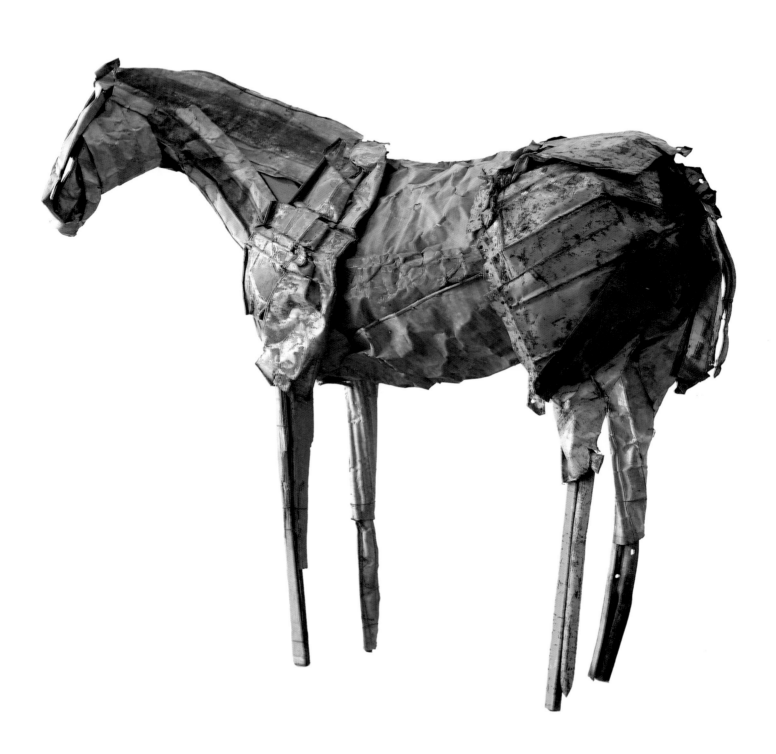

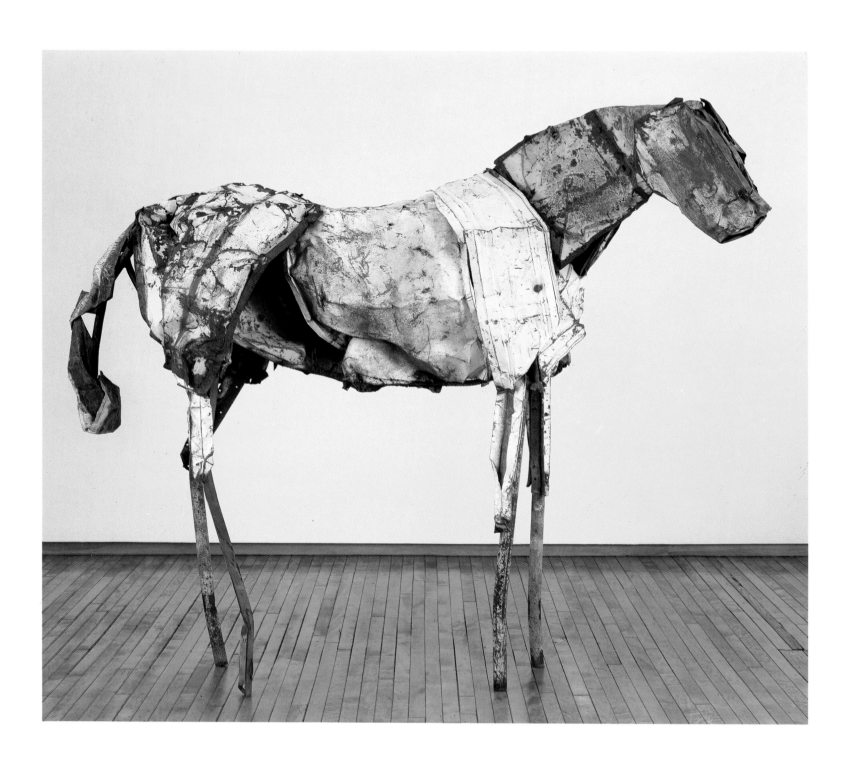

dance with somebody who can't talk to you. And each person that you dance with is very different. It has so much to do with language; it has to do with presenting information so that another creature can understand your intention, so that the movement that you both create can have meaning.

This translates into my studio . . . I can't quite figure out the exact way that it does. Maybe if I do, I won't be needing to make art any more, because it's a nonverbal thing that I bring back from the horses.

It also has to do with peripheral vision a little bit, and the sort of stopping of action, like a stroboscopic, freeze-frame type of perception, of activity and animalness in your periphery, which I think is how horses perceive. They are basically dinner for carnivores, and their eye structure is such that they can be standing up or grazing and their eyes will see almost in a 360-degree view. For example, my first horse and I were riding down this road, and we both saw a wild boar coming up at us out of the ditch, and we both nearly had heart failure. We regained our composure and both of us realized that it was a log on the side of the road with sort of earlike things and an open mouth. And then we were both totally sheepish and embarrassed but our hearts were pounding for about another half-mile. That we both perceived the same inanimate object at the same time and were both afraid for our lives, is sort of what I'm trying to do. I'm trying to get that kind of . . . what is that called, it's anthropomorphism, projecting life into inanimate objects.

It's about that kind of perception on the edge of things, and that's why my work is not so overtly about movement. My horses' gestures are really quite quiet, because real horses move so much better than I could pretend to make things move. For the pieces that I make, the gesture is really more within the body, it's like an internalized gesture, which is more about the content, the state of mind or of being at that given instant. And so it's more like a painting, the body of the horse is really . . . the gesture and the

. . . The horseman shares with the mathematician an ability to be commanded by beauty, even in the face of paradox, and for both the need to make the right distinctions between the beautiful and the merely pretty or picturesque is a condition of survival as a genuine thinker.

VICKI HEARN
ADAM'S TASK:
CALLING ANIMALS BY NAME

JERUSALEM HORSE V
(WAR HORSE)

1980
steel, wire, metal

movement is all pretty much contained within the body, which is pretty rectangular and pretty much about the edge and the silhouette and what kind of activity is happening within that frame, as in a painting.

MT: You mentioned something the other day about the horses' language. You had started to read me something . . .

DB: It's a quote from Vicki Hearn's book, *Adam's Task: Calling Animals by Name.* She's really interested in Wittgenstein, who wrote: "To imagine a language is to imagine a form of life." And I guess that my work with the real horses is so much about language and that my art has to do with imagining another form of life. It's that empathy; I'm trying to get the viewer to project himself or herself into the form of the horse. I want people to actually be able to crawl into that shape and inhabit it, and to perceive in a different way. Even when content isn't specific, that act of getting out of oneself and making that transference can be earthshaking. I also feel that content can be abstract and yet felt; it's like spring steel. Somehow by hammering the energy into that steel it's still perceived even though the work is silent in terms of English, or German, or whatever.

I built a show in a month in Jerusalem, in 1980, and it was a really intense and emotional and yet remarkable experience to build the work in a city like that, using materials that had in many cases been caused by the war. The material had innate history and content, and then just in making the horses, I put my own energy and content in it, which was not literal. The work then went to Germany and some of it went to England and then to the United States, and people see the work without even knowing where it came from, and they seem to pick up on what the work is about. I believe that if energy is put into something it will somehow manage to be there and to be felt, even if it's not in a very literal and easy-to-read sense. So that which is

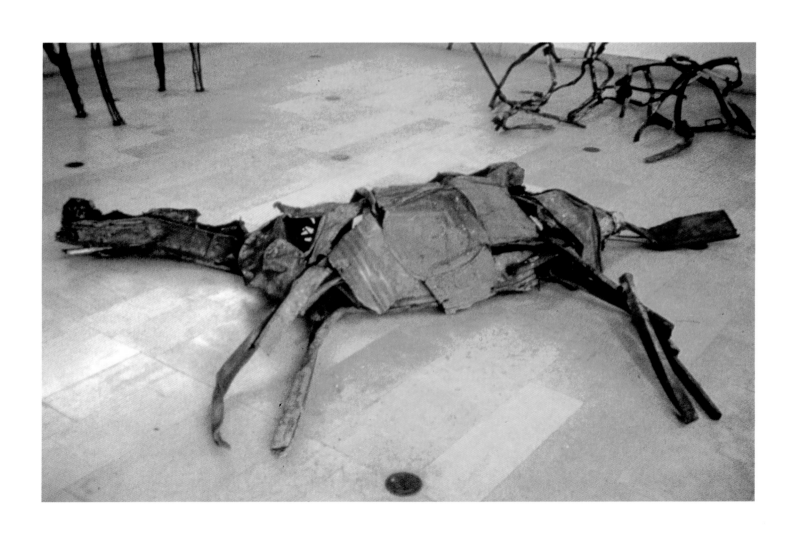

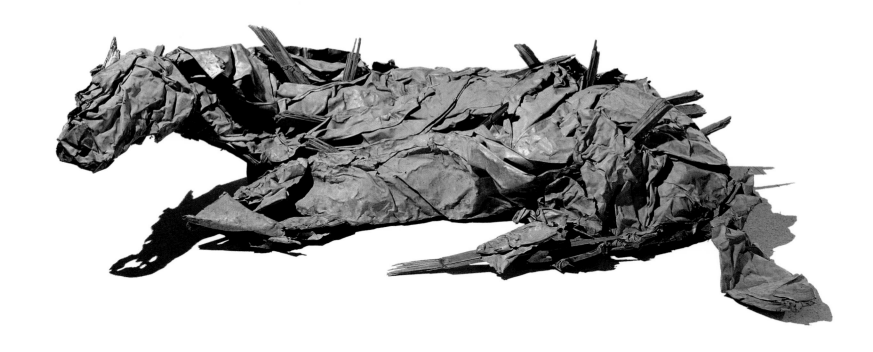

ROSARY

1981

wood, sheet metal, brick dust

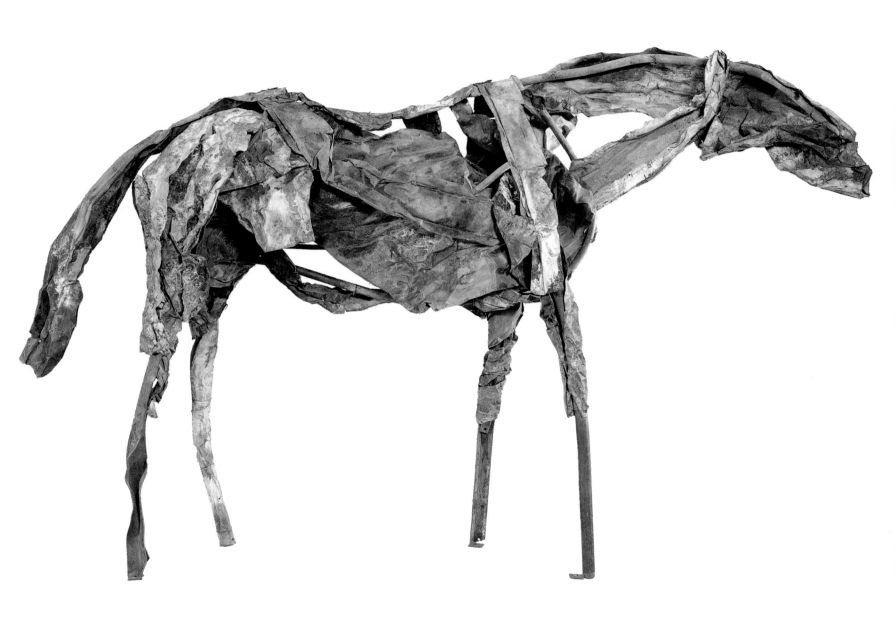

H O R S E

1985

painted and rusted sheet steel, wire,

steel tubing

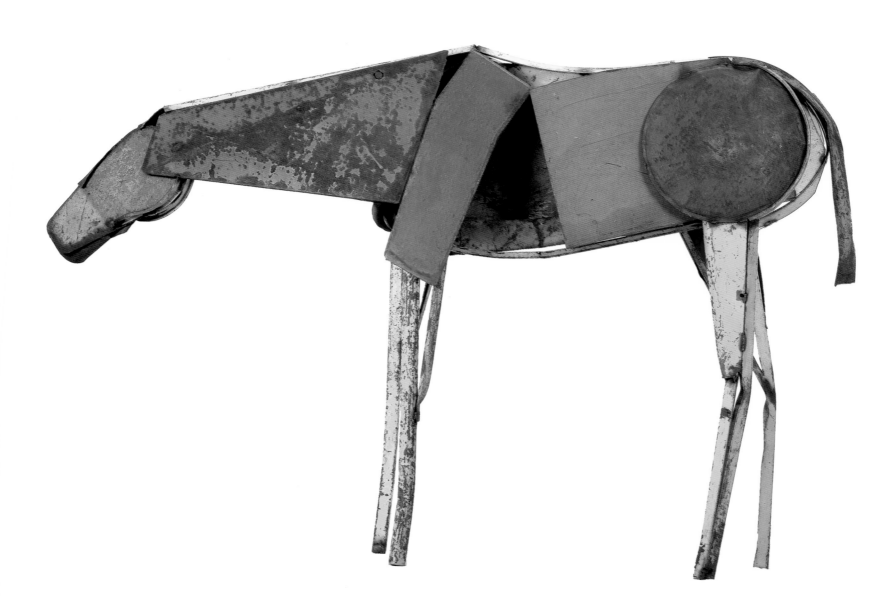

political can take direct, literal, communicative form, but it also can be subversive, in a more quiet way.

Besides, I feel that there is the politics of animals. A lot of people try to compare my work to Gericault's, and a lot of these artists who I have little interest in. I admire Stubbs's work and such, but I really . . .

MT: You mean you're not to sculpture what Rosa Bonheur was to painting?

DB: Right. (Laughter) In fact, I've hardly even taken an art history class on European art. I've concentrated on Asian art, African art, American Indian art. I had to take a Northern Renaissance painting art history class once, but that was about it. I'm just not interested in our classical European tradition, at least until the modern phase. The other day it dawned on me that I don't buy the whole thing, the basic premise of the Bible, which is about sixteenth-century European writing; I don't believe that man has dominion over all things. I don't start from that basic premise. And from that point on, my work is very different. I guess that's where the real horse is important to me, because while I feel that horses are not intelligent at doing things that people do or that dogs do, they're very intelligent at doing things that horses do, and I'm interested in what that has to teach me. I'm interested in another species' perspective on our world, and that starts to get political.

MT: What I'm trying to do now, in my own work, is not to be afraid of contradictions, of being open ended, of not having it tied up nicely, not to even necessarily need the pure beginning, middle, and end, which is so indigenous to modernism. You know, Jane Gallop talks about this in her preface to *Reading Lacan*; at the beginning she says that perhaps the most profoundly feminist act would be to relinquish authority from a position of authority. As soon as people turn to you for your expertise, to let that go and talk not about what you know, but about what you don't know. That is a very real, political thing

PALMA

1990

steel

to do. Those in a position of authority, those who cherish the masculine, paternalistic world, are simply not going to. That couldn't be a goal for them as human beings.

DB: My first show in Chicago was horses that were mud and sticks, but they were mostly lying down. The materials were very important because they portrayed the horse as being inseparable from the environment, in fact, made of the environment, literally. But the posture was what was so important at that time, because at that time the horses that I was making were all mares and they were sort of self-portraits. Well, they weren't all mares but they were about being mares. And my original take on it was that we all think of horses as standing on four legs looking proud and noble, and the symbol of a horse—like you would see on a street sign saying Horse Crossing. But I thought of mares as being female, and started thinking about the female figure in art history, and how you think of mainly reclining nudes throughout history, the sort of voluptuous female form, lounging around, being seductive, and so I immediately thought, how fabulous to have these huge, round, sensual mares lounging around an art gallery on the floor, resting—sleeping. And then I thought, I can take it even further, because a horse can sleep standing up. They're built so that their legs lock into position, and they sleep with their nose nearly touching the ground, so that if a predator comes, they can run in nearly an instant, at an instant's notice. They're built to flee. However, a horse will lie down—of course they lie down when they're ill—but my horses lie down all the time because they feel secure and confident in their environment. They feel safe.

Well, I thought, if the horses are me, and I'm lying down in an art gallery, it is a very vulnerable position to take. There are these wolf critics walking around, and all kinds of weird people, and to make oneself vulnerable in a situation like that is to express a position of strength. And I think that's

UNTITLED

(DRY FORK SERIES)

1977

mud, ground paper, dextrine, grass,

steel, chicken wire

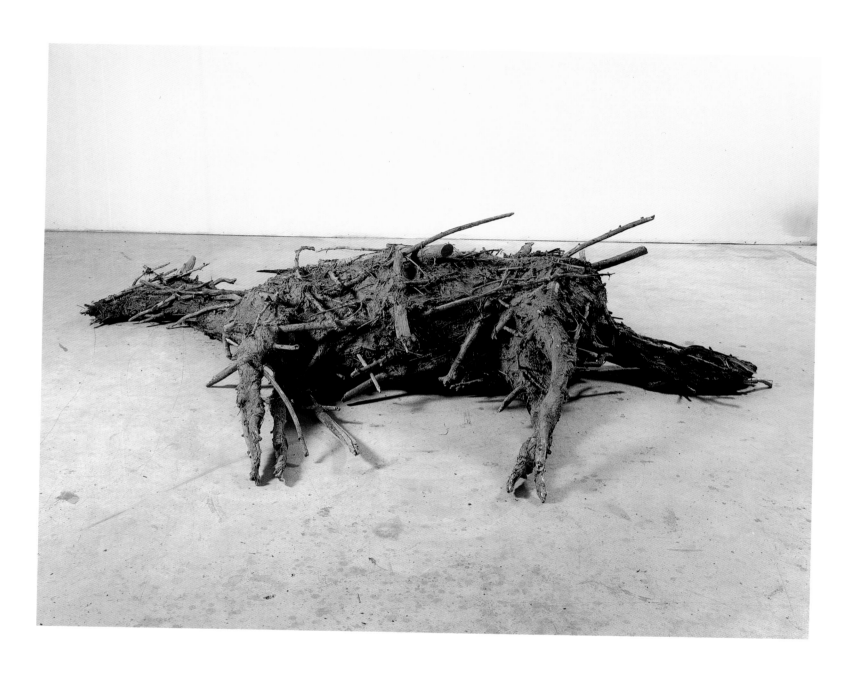

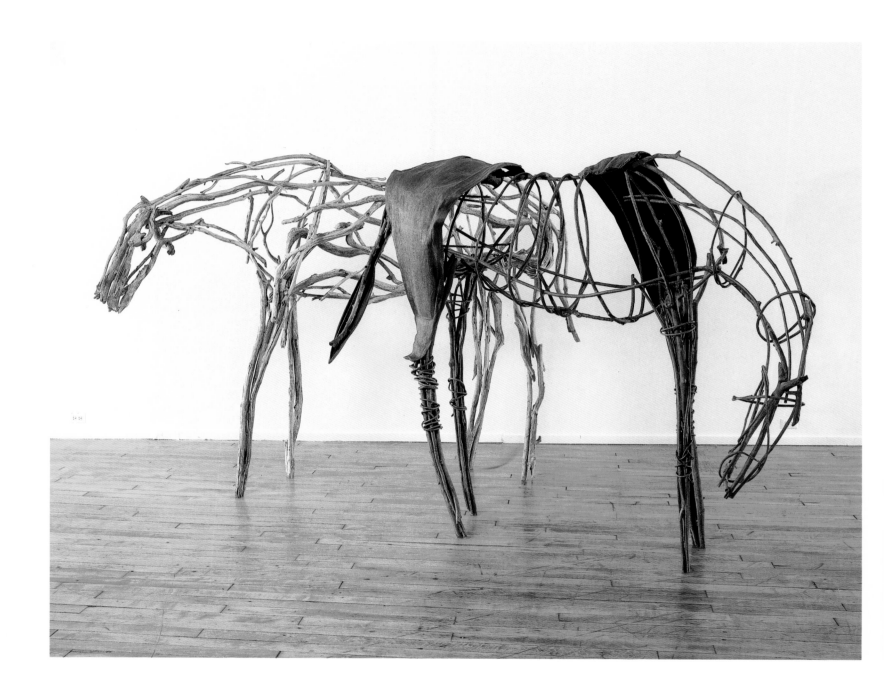

LAPU

1990

cast bronze with patina

LAKA

1990

cast bronze with patina

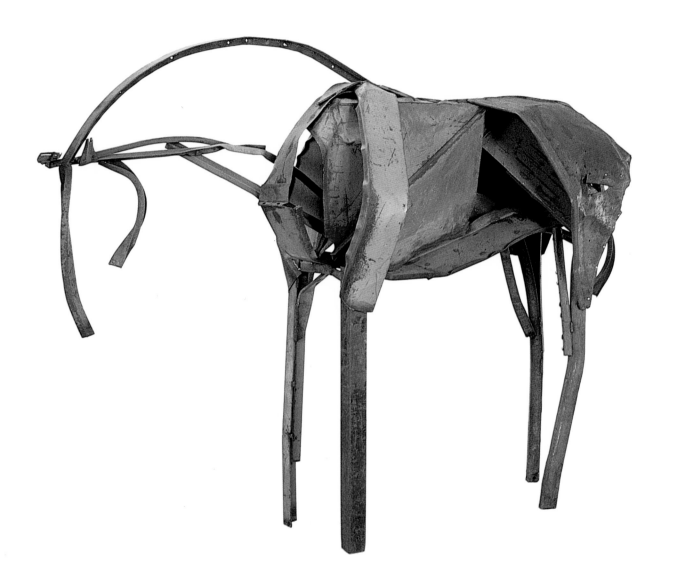

VERDE

1990

steel

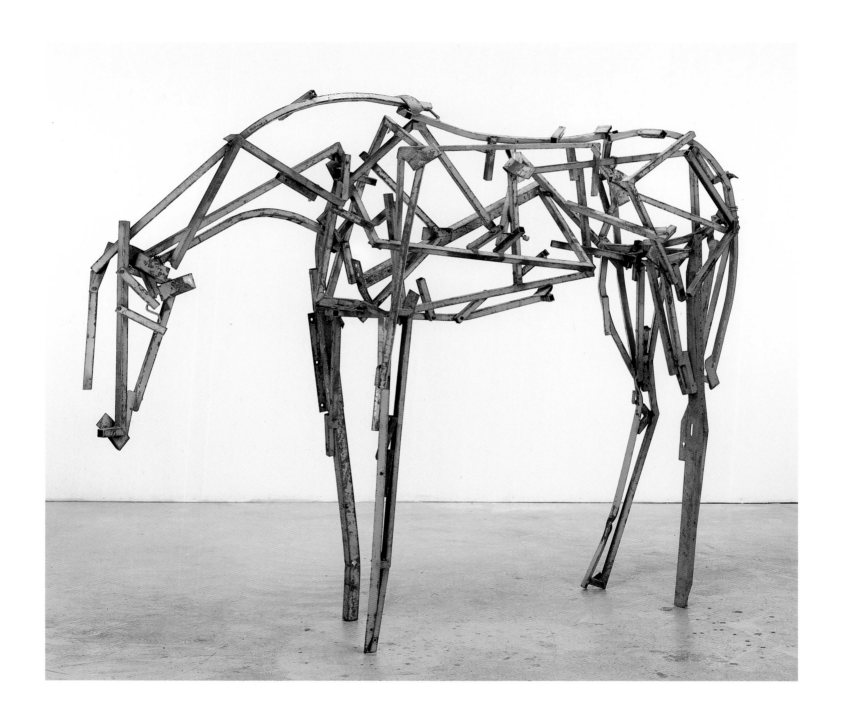

what you're talking about—to make yourself vulnerable expresses a sense of one's own power.

MT: What about the physical act of making the horses, the purely sculptural or technical aspects of your work?

DB: Well, it brings me back to that quote: "To imagine a language is to imagine a form of life." And I guess that by language we're essentially talking about a structure upon which we hang or present different ideas, and I guess I think of that as a metaphor for how I build my work, like diagraming a sentence. There's always some sort of a premise that isn't even a verbal premise, but is just seeing how different kinds of things physically hang together. It's a physics of attachment, which is sort of different in each piece, and has to do with a different emotional content or a different structural premise, basically, which I think equates with language, particularly the way that you use language when addressing a different species.

If you're training a horse, the most important thing is that you make your requests clear. You have to present your ideas clearly and consistently. If I'm asking the horse to do a specific maneuver, I have to ask him the same way each time, so that he can memorize the feel of what I'm asking. And when he does it correctly, there's a physical sensation . . . I don't know if it's joy, but it makes the horse feel good when he does something right. It's almost as if you can see a little light bulb go off in his head, and he'll kind of gesture to you—it's hard to explain how he does it, but it's as if to say, "Is that what you meant?" or "This feels good. Is that what you want? This is what you want, isn't it?" Which is really exciting. And the two of you discover the right thing. It's uncanny how both of you will be muddling around and muddling around, and then when something is right, you'll both know it, at almost exactly the same instant. And you can see the horse's neck and back

REX

1991

steel

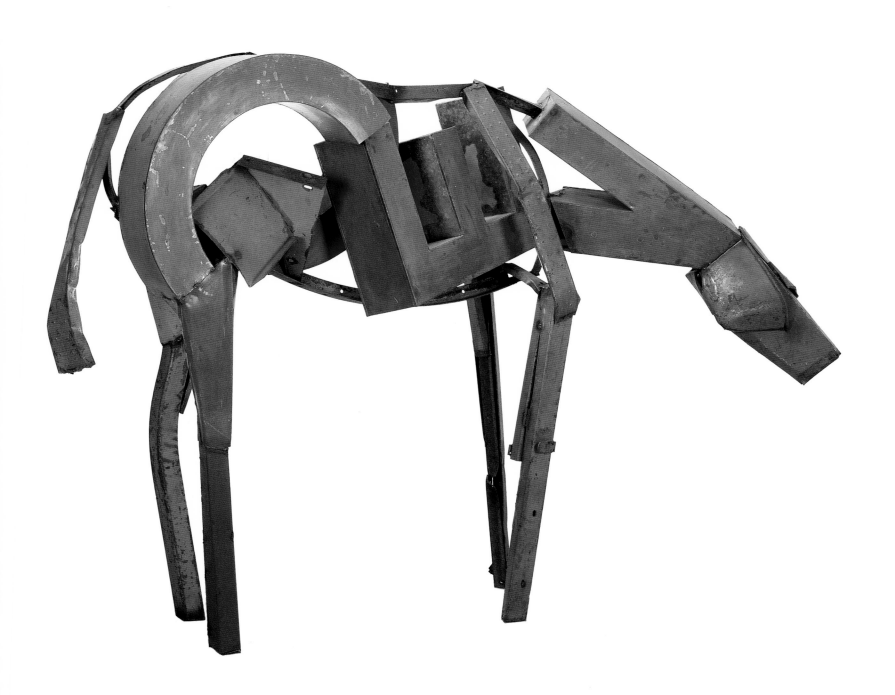

relax, and his ears will sort of do something towards you, and there's a happiness that kind of comes out.

I don't know how much this has to do with art, but it certainly has to do with communicating. I'm not quite sure how I bring that back into the studio, but I do.

MT: If you didn't ride, do you think you could still make the horses?

DB: In fact, I started making the horses when I wasn't doing very much riding. My mare was pregnant at the time, and I didn't have much time to ride. I know that riding isn't necessary, but it makes the work different. I suppose in the same way that your work is different when your body is different . . . the work is different depending on what kind of relationship I'm having at the moment with the horses.

One of the interesting things about dressage is that when the judge watches you ride, he not only notices that you do the prescribed movements correctly, but he looks at the way the muscles are made on the horse, and if they're not situated on your horse properly, he knows that your training is incorrect, and so will be more critical of your movements. So by training a dressage horse you're making a sculpture, because you're redistributing the muscle structure of the horse.

So I find myself building my sculptural horses the way I'd like to build my real horses. It has to do with a certain kind of balance in their structure. And it bothers me in many ways, because I feel as if I'm perhaps addressing a more narrow framework of horse stuff, that I'm avoiding the starving range horse of Montana or the bronco in the rodeo or the quarter horse. I mean, I'm interested in a horse that's also interested in a kind of art form. So the shape of the horse is different.

FERDINAND

1990

steel

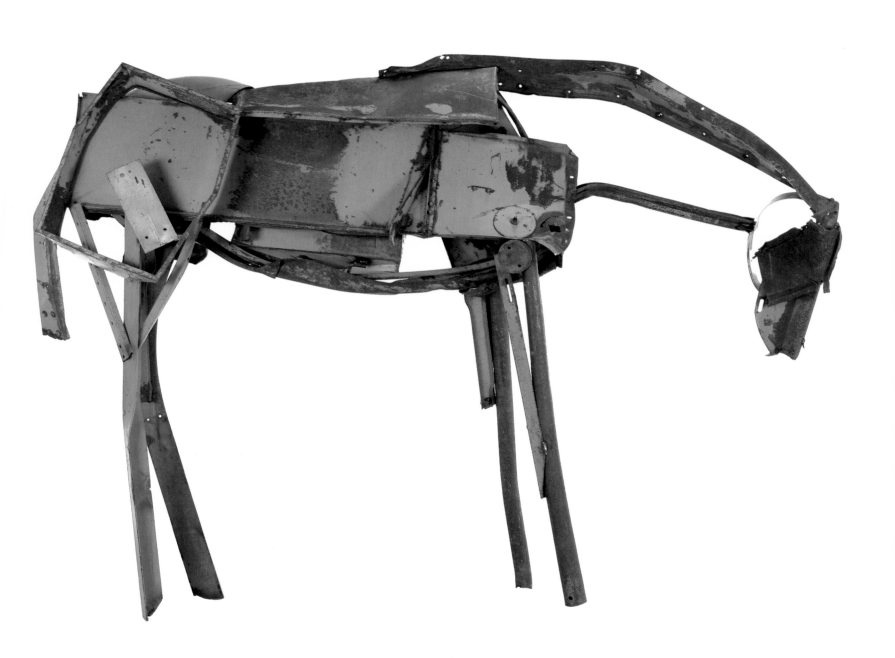

MT: I think it's important that people understand that you don't just sort of sit down and copy a horse, or that you don't have the horses around so that you can use them as your models, which isn't the case at all.

DB: Well, I do use them as models, but I use them less by looking at them than by touching them and riding them and discussing with them. And it's funny, I never really go out and look at them while I'm working. I'll carry them with me in my mind. I guess you sort of cherish another being by remembering it precisely, or even . . . I never really do remember it precisely, I always enlarge. You know how when you think of someone with great love and joy you kind of expand them? They become bigger . . . and that's what happens with the horses, and why they're so much bigger than real horses would be, because their being can become overwhelming on recollection. You composite all the moments that you can think of into one moment, and so it becomes more than real life.

When I'm actually working, I go in and out of emotional involvement with the piece. While I'm making it, I'm quite brutal. To make the sculpture is a physically brutal process; you're sledgehammering and cutting with a torch and knocking things around, and it's kind of weird to be doing that to a thing that has a head and a neck . . . and yet I'm totally ruthless and have no kind of emotional contact with it until I'm done. And then I still feel kind of strange about it, it's only much later that I let my guard down.

D A Z Z L E

1990

steel

MT: Unfortunately most people looking at a work of art have no relationship to the artist, and a lot of things aren't perceptible in the work when people are looking at it superficially. It's very hard to say to what extent our knowledge of the artist's thoughts and feelings influences our ability to establish a relationship with the art.

DB: It goes back to what you were saying about intent having very little to do with the end result. I was trying to say that I felt it stayed there, but that

it wasn't directly translatable. The artist puts it in, and the energy remains there, but each viewer brings to any given work their own life experience.

MT: And also a very limited amount of patience. Most people don't look at works of art very hard or very long. Most people don't live with them, don't go back a second time to see them. Most people take time with what they're already familiar with. There are so many variables in looking at art, and most people who look at art do so from a position of knowledge and familiarity, and go from there. Trying to get someone engaged with what they're not familiar with is a very difficult process, and to do so it has to be already in the work itself; that is, someone who isn't already involved with art would have to care about horses in order to engage with your work initially. Fortunately, horses are a very powerful presence in the world, so that people might actually stop and look at these things, or feel them, or give them a little more attention than they normally give to works of art.

DB: It's like music. People like hearing music that they've already heard.

MT: And people like telling stories that they've already told. Children don't want to hear a new story every time, they want the old one.

Well, if you could do anything, what would you change in the world?

DB: I guess if you could make everyone clean up their own backyard, it would be a good start. (Laughter)

KOSMO

(detail)

MT: It would be a very good start! Many people feel so powerless in the fact of the big picture that they just drop it out of consideration.

DB: Well, you do feel powerless in the big picture, but I guess it begins at home. If you can't set an example by your own actions, then you're foolish to try to fix someone else's actions. You have to start with yourself, and work your way outward.

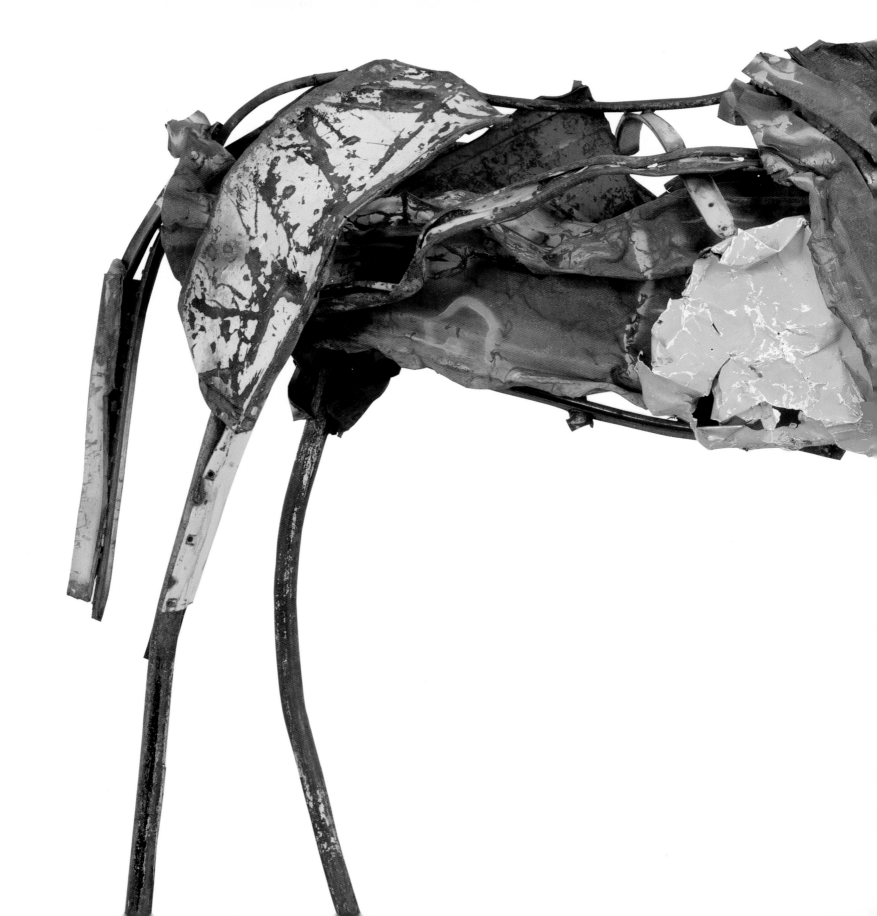

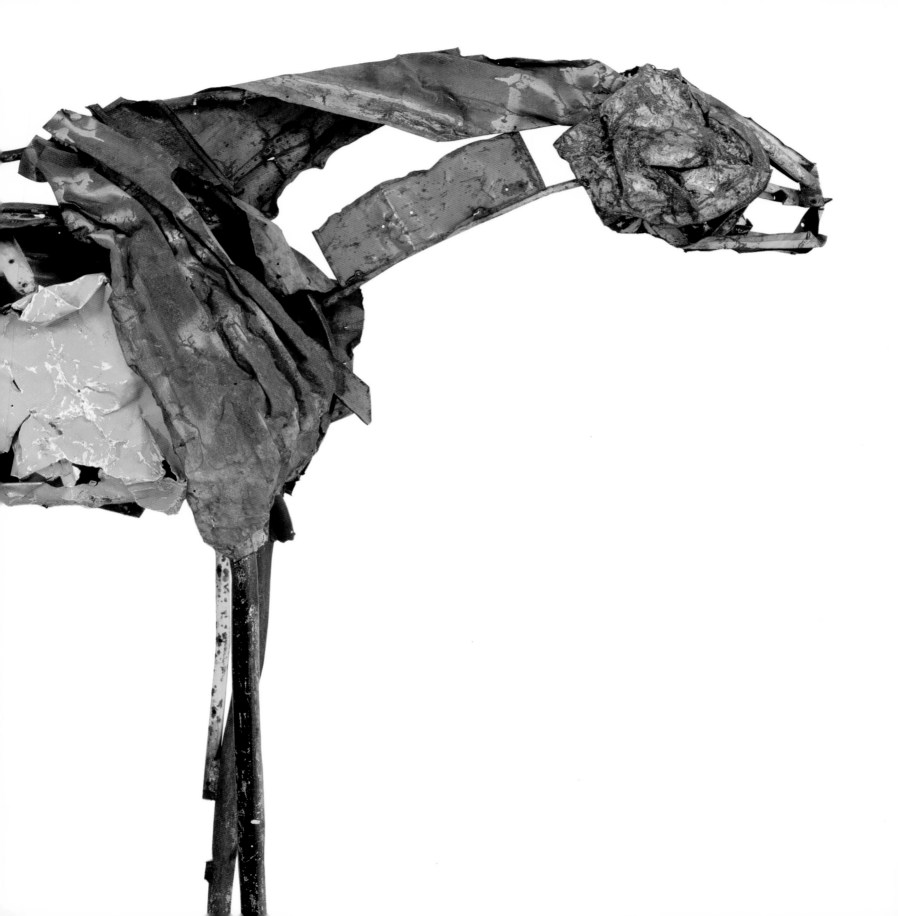

THE HORSE IN THE INDUSTRIAL AGE

DEBORAH BUTTERFIELD'S SCULPTURES

DONALD KUSPIT

"In the human imagination of all ages," Ernst Jones writes, "horses have been extensively connected with ideas of the supernatural. Not only evil demons and lecherous visitors of the night, but Divine beings themselves have frequently assumed an equine guise, and, as elsewhere, the good and evil supernatural beings pass insensibly into one another. In Hindu mythology it is taught that the first horse was created as a by-product when the gods and demons were jointly churning the Ocean of Milk to extract nectar from it."[1]

How does such an extraordinary, age-old symbol of the drivenness of psychic life—especially of its ambivalence and bisexuality—survive in the industrial age, the modern world of technology? Is the horse still magical in a world of "instrumental technique," to use Jacques Ellul's term,[2] or of "instrumental reason," to use Max Horkheimer's more comprehensive term, conveying, not without irony, the idea that reason comes into its own when it is no longer absolute but "accepts itself simply as a tool,"[3] forfeiting its criticality? What spiritual sense does a horse make in a world in which "technology has

KOSMO

(detail)

57

not only taken bodily possession of the human being, but also spiritual possession," a world in which "a technological veil" has been cast over perception and imagination, stupefying them?[4] How can the horse, a mythopoetic symbol of emotional spontaneity and irrationality, continue to be a viable symbol in a world in which the irrational has been rationalized, scientifically studied, mastered, "modernized"? How can the horse make artistic sense when the emotional force it represents has been abstractly formularized — made facilely intelligible? What emotionally organic sense can the horse make when organic reality seems to have lost its naturalness?

But even in a world in which scientific technique aims at the "elimination of all human variability and elasticity," a world in which the living organism is either replaced by a machine or modified "so that it no longer presents any specifically organic reaction,"[5] the horse has been enshrined in imagination as the one living organism that cannot be completely broken in and down. It seems to retain its power of organic reaction even after it has been domesticated, disciplined to human use, become a prosaic instrument. It continues to be unconsciously experienced as irrepressibly vital, to the point of unpredictability, an agent of organic revolt against the inorganic world of technology. Perhaps because of its long association with man, the horse has achieved the mythical status of representing his own unconscious unwillingness to submit to the yoke of the society he has consciously established.

The horse plays a permanent symbolic role in human self-conflict. In the modern technological-scientific world, in which the organic has been read away by becoming a text to be systematically decoded and mastered, the horse signifies unsystematic resistance to the system by representing the incompletely masterable, indecipherable animal within us. The horse is a reassuring symbol, however much the aggression it represents is recognized to be futile and absurd. Identifying with its enduring naturalness, we think we can inwardly hold out against the artificiality technology has created, and

KOSMO

(detail)

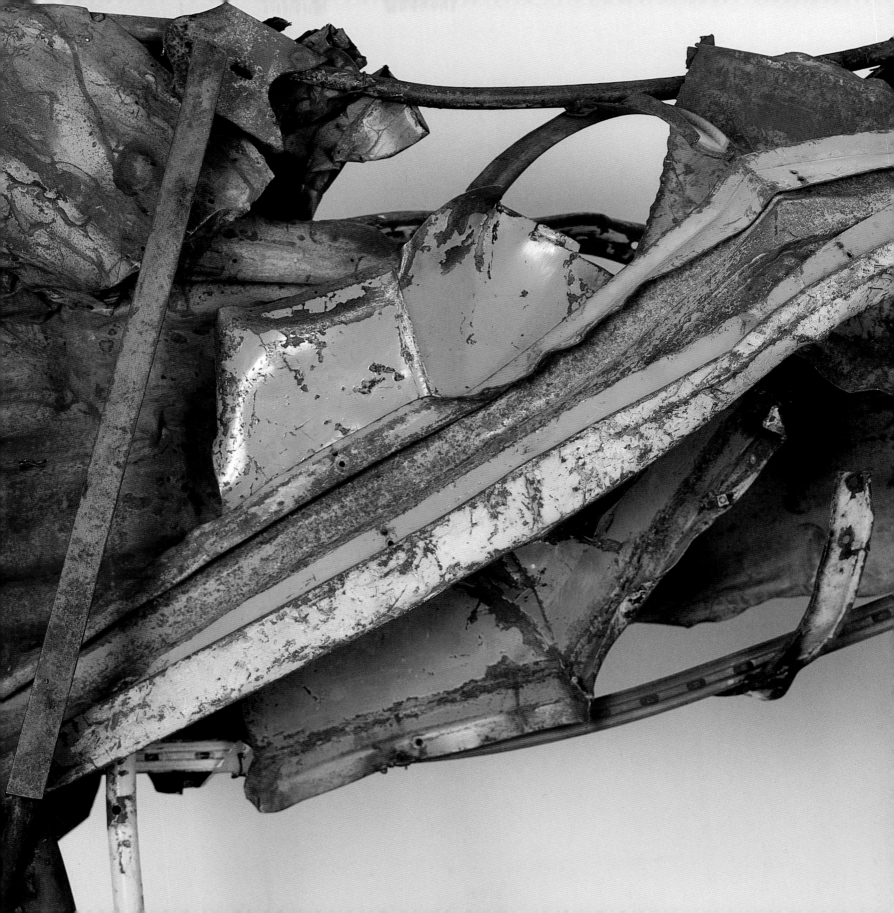

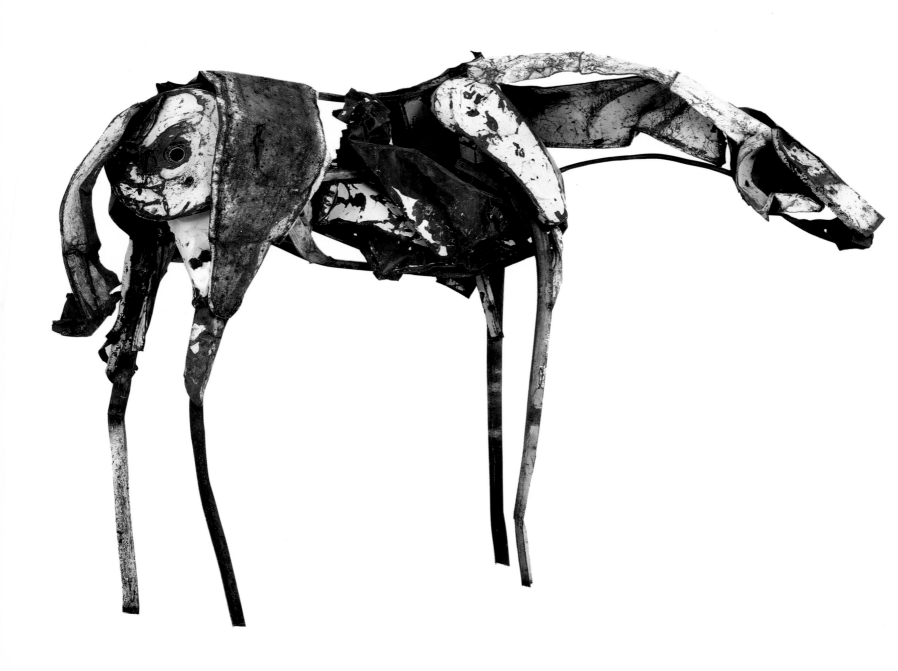

against technological control of our individuality. The horse represents our wild outrage, as though wildness could only appear as loss of control in a technologically perfected, overcontrolled world. In a sense, the horse represents the disruptive stranger, as Georg Simmel called it, the "inner enemy" who seems outside society but confronts it from within.[6] The horse is a memento mori, a perverse reminder of the instinctive life technological-scientific society has repressed in the name of instrumental reason.

Instinct is especially disturbing because of its confusing dialectical quality: it is simultaneously somatic and psychic, existing on and bespeaking the uncertain border between body and mind. As such, instinct contradicts the Cartesian theory of the separateness of mind and body, which is the basis of the modern rationalization and instrumental control of experience. Each is disruptively latent in the other, making itself felt through its power to "influence" the other. In a sense, each is only fully itself when its suggestion sways the other. Thus, not only are mind and body impure—each is subtly dependent on the other for its own life—but their relationship is perverse, dissolute, and erratic. They sometimes seem so insidiously intertwined as to appear inseparable, each not only the agent for the other but the other in different form.

Butterfield's horse bespeaks instinct, but it is instinct crippled by technology and instrumental reason. It is instinct deformed by repression to the point of denial. It is a paradoxical horse: a technological "invention" that is antitechnological in import. In technologically rational society the Cartesian assumption of the separation of mind and body has become gospel, no doubt an intellectual apology for the social manipulation of both. (One divides to conquer, as the saying goes.) Such separation amounts to the repression of the irrational body by the rational mind. More particularly, the body is split into irrational and instrumental parts (echoing the original split of human substance into body and mind); the irrationalized body is repressed by the

instrumental body, which represents technological reason. Butterfield's horse not only represents the return of the repressed irrationalized body — the body conceived as devilishly driven substance — but its ironic integration with the instrumental body. Butterfield's horse represents the ruin the body has become in the service of instrumental reason. That is, her horse is industrialized instinct, as it were, as well as instinct rebelling — with ambiguous success, the horse's appearance suggests — against its industrialization into fuel for the social machine. Butterfield's horse articulates this demented situation: it is the self wounded to the quick by technological reality, and the self trying to reconstitute its own integrity, to heal itself. In a sense, her horse represents postindustrial instinct — instinct that has survived, in however lame a form, its industrialization. Her horse is a survivor that looks like an ironic resurrection. The rust that often appears on her horses is not unlike that of the "rust belt," a sign not so much of the obsoleteness of certain industrial methods as of the devastating existential effect of industrialization in general.

Thus, Butterfield's horse articulates the corrosive effect of instrumental reason on industrial man's body ego: underneath his robot exterior, he unconsciously experiences himself as damaged in his deepest self. Her horse is his body image, bespeaking the secret suffering induced by becoming technologically "correct." It is the hidden side of the obliging robot self, programmed to be a social instrument. Butterfield's horse is a profound critique of industrial society, and profoundly true to its time: it is impossible for her to recreate the vigorous, healthy primal horse of mythology; her horse must look like a wreck to tell the pathological truth about the world instrumental reason has wrought. Her technological vision of the horse bespeaks the sense of destroyed self privately pervasive in technological society.

It is worth noting that Butterfield's disintegrating horse has an ironic relationship to the muscle-bound bodies that the popular culture flashes at

JUNO

1989

cast bronze with patina

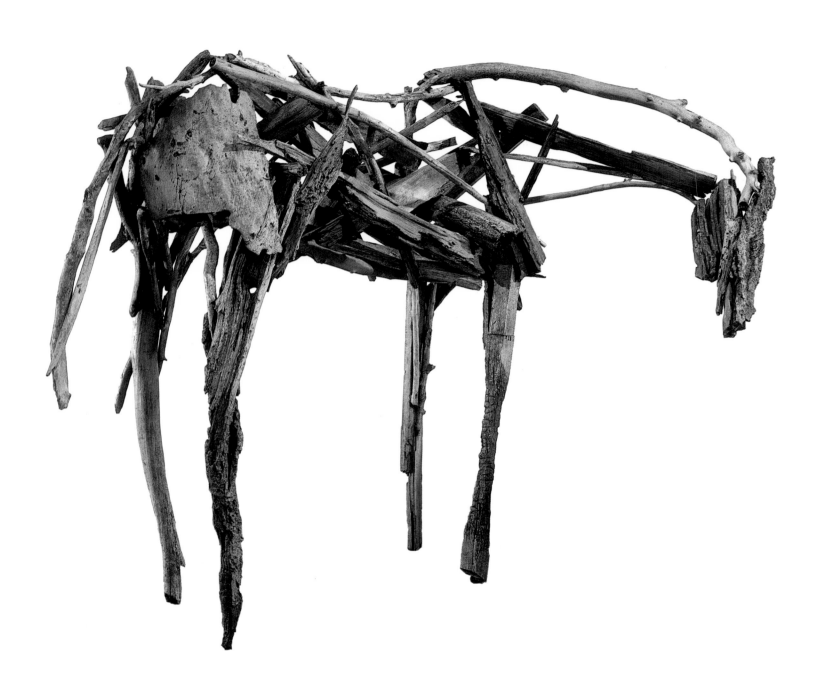

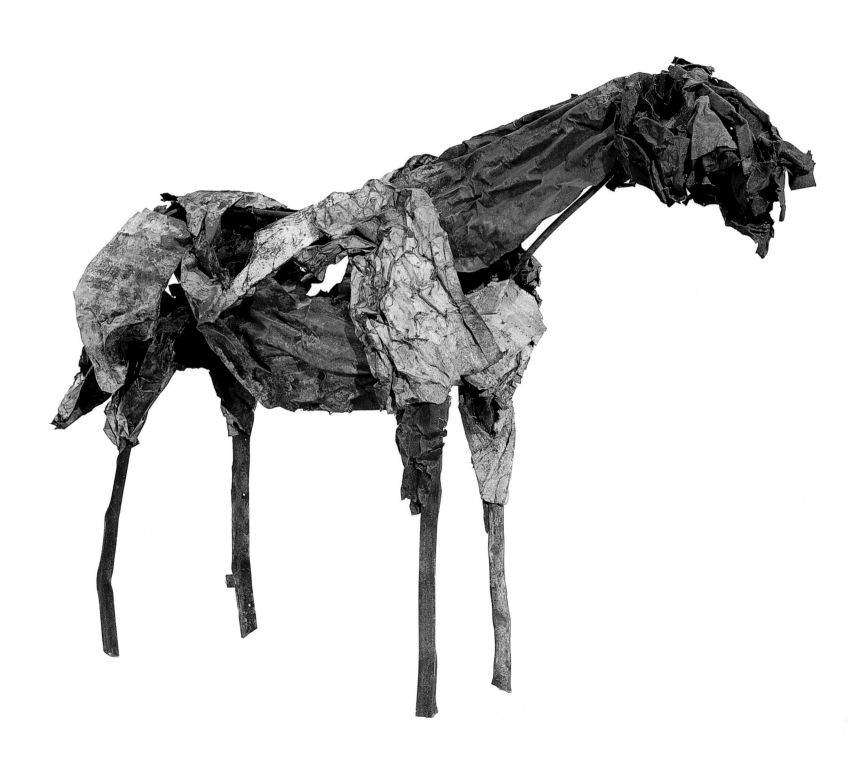

us these health-crazy days. These falsely whole bodies are more than simply physically fit, and not exactly healthy. They are perfect robots, accurately externalizing the internal sense of being an instrument. At the same time, the obsession to build such a mechanically ideal body is an attempt to heal a severely damaged body ego—the other side of the split.

Before the automobile, the horse was the major means of transportation, and as such a common sight, taken for granted but still, like a day residue, an object around which unconscious associations and meanings accreted. Moreover, however degraded to a commonplace instrument, the horse still retained something of its traditional heroic meaning. When a person mounted and rode a horse—was lifted off and elevated above the earth, viewing it from a loftier perspective—he unconsciously felt something of the seriousness and high purpose conveyed by such equestrian statues as that of the Emperor Marcus Aurelius, ca. A.D. 165, and Donatello's Gattamelata, ca. 1445–50. Man invested himself in the power and seemingly noble uprightness of the horse to the extent of identifying or merging with it. The horse represented his own animality socialized and sublimated to higher aims. Today the horse is neither an everyday appearance nor a particularly useful instrument nor a vehicle of heroic intention, but a novelty and plaything. As such, it is an abortive symbol of freedom, whether physical or expressive; that is, the horse has become amusing. Ellul remarks that "amusement seeks to distract, propaganda to lead."[7] Where the horse was once paradoxical ethical propaganda—it was an animal that symbolized the possibility of man becoming godlike—it is now an elitist diversion from the serious technological business of existence. Elitist, not only because horseback riding is an uncommon sport, but because it has aristocratic associations, based on the old equestrian image. Riding a horse, a modern person still has the illusion that he is "the author of his destiny," while everything in his life tells him

M A L U H I A

1986

steel

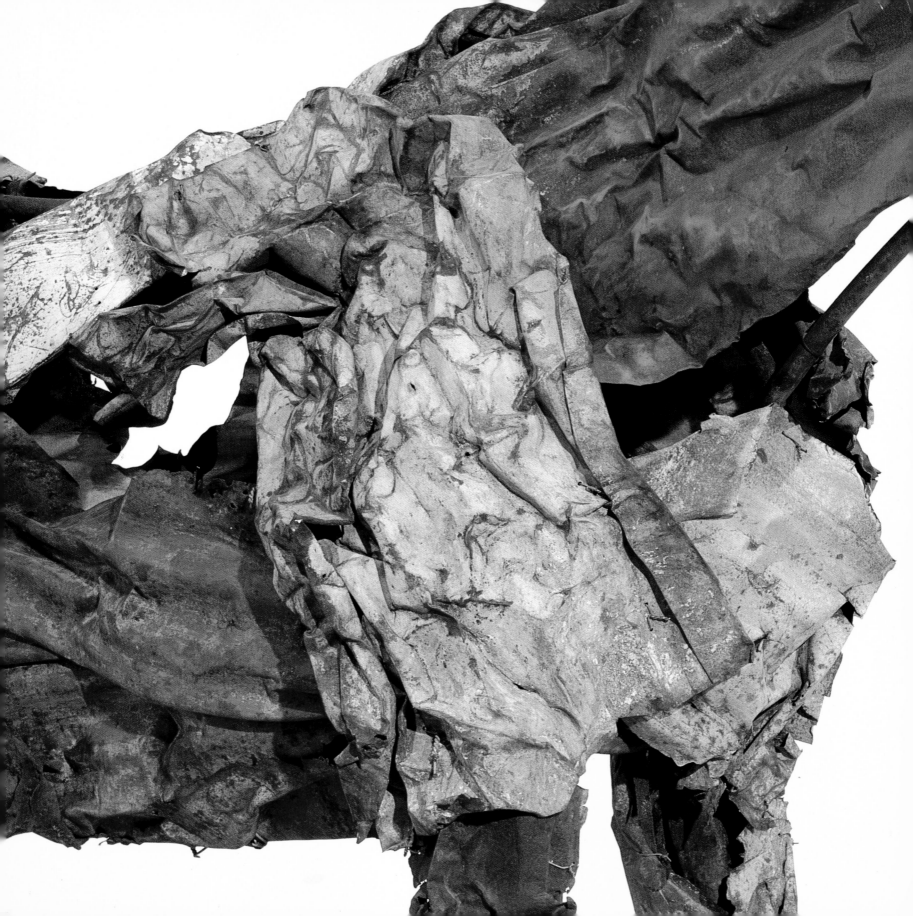

that this is far from being the case: "the image of an insecure world" haunts work that betrays his humanity, giving him the feeling of "being torn between the extremes of accident and technical absolutism."[8] Mounted on a horse, one's sense of being a higher, freer, more formidable being rather than an industrial drone returns; life feels fresher and brisker, and as one rides toward the horizon, it seems full of infinite possibility.

But Butterfield's horses are not the noble beasts of the superior equestrian rider. Nor are they presented in human company. They exist in their own space, far from human space. This is the first step in the restoration of their primal character. But, as I have suggested, they can never again be fully restored—whole and intact. In a sense, they are the waste products of human industry, being made of industrial debris, generally steel or sheet metal. They exist in a fragmented state, their parts barely holding together. They are through and through technologized, as it were. They are ironically insubstantial, made of seemingly durable modern material, but full of holes and fractures, and hollow at the core. They are modern ghost horses—industrial versions of the horse Death rides, as in Albert Pinkham Ryder's *Death on a Pale Horse*, ca. 1896. Indeed, they are in and of themselves triumphs of death, embodiments of death. But not death in the old sense, rather modern death, living death. They do not have the organic look of death in Hans Baldung Grien's images, but rather the inorganic look of modern death. They do not symbolize traditional death from natural causes, whether pestilence or old age—the death that always reminds us that life is short however long it is—but rather modern death from instrumental reasons, from "technical" social causes. In this death, we continue to look alive—at least superficially—but are inwardly dead, out of touch with our vital selves. In this death we are dead before our time, however short or long it may be. Today we have been destroyed not only by outward but inward robotization, deadening our critical awareness and spontaneity—indeed, eliminating the possibility of iron-

MALUHIA

(detail)

ically distancing ourselves from life in order to make an emotional clearing in which we can enjoy our natural vitality. Butterfield's horses are composites of fragments, precariously upright—some even recline in total collapse, more or less coming apart—for example, *Jerusalem Horse V*, 1980 (p. 39), and *Rosary*, 1981 (p. 40)—and as such represent the living death of the modern self, its corroded, fragmented, tenuous state.

But Butterfield's horses, whether literally or figuratively dead, are also full of instinctive life, as noted. They are the victims of the technology they literally embody: they seem to be rotting from some disease that infects machines and the modern materials out of which they are made. But they are also alive with color, however partial and at times muted. Indeed, they are a patchwork of colors as well as of metal. Death may have been forced upon instinct by instrumental reason, but instinct, like Lazarus, can rise from the grave in a forceful blaze of awkward color. The horse, after all, is still resonant with the power of the id, to allude to the analogy in which Freud describes the id as a horse that the rider ego imagines it controls, but which in fact goes where it wishes.[9] This primordial sense of horse—the archetypal "imago" of the wild horse—remains alive in Butterfield's industrially disturbed horses.

Butterfield's rotted metal horse, however, is hardly all id, full of "the wild thing's courage to maintain itself alone and living," to use the words with which D. H. Lawrence described the horse hero of his story *St. Mawr*.[10] "St. Mawr, that bright horse, one of the kings of creation in the order below man," had found fulfillment in serving "the brave, reckless, perhaps cruel men of the past, who had a flickering rising flame of nobility in them." It obliged man "to be brave, and onward plunging. And the horse will bear him on."[11] Butterfield's horse is neither unequivocally bright nor kingly, and does not bear—nor is it strong enough to carry—brave, hard driving, onward plunging man. Rather, it represents man who has lost his nobility and reck-

JOSEPH

1988

steel

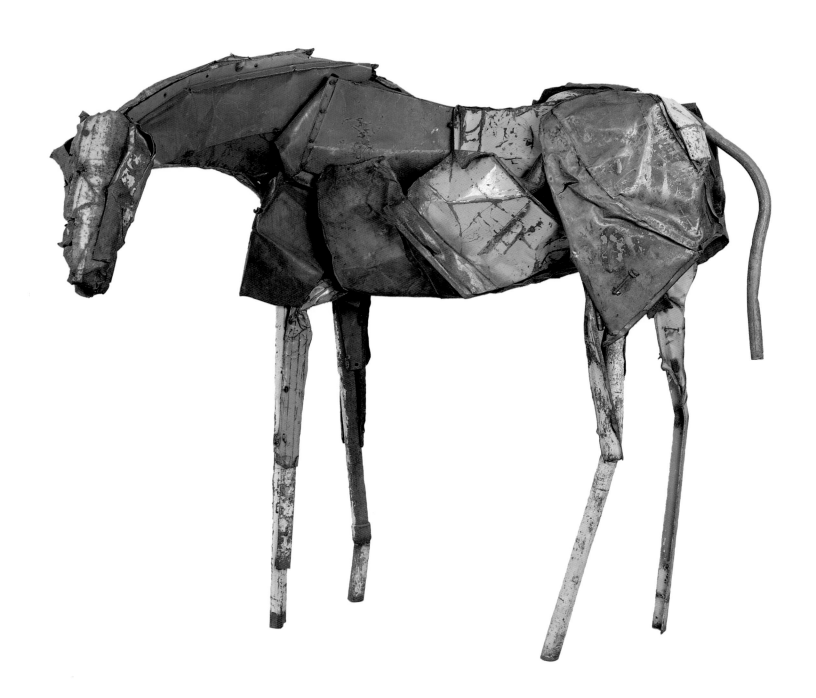

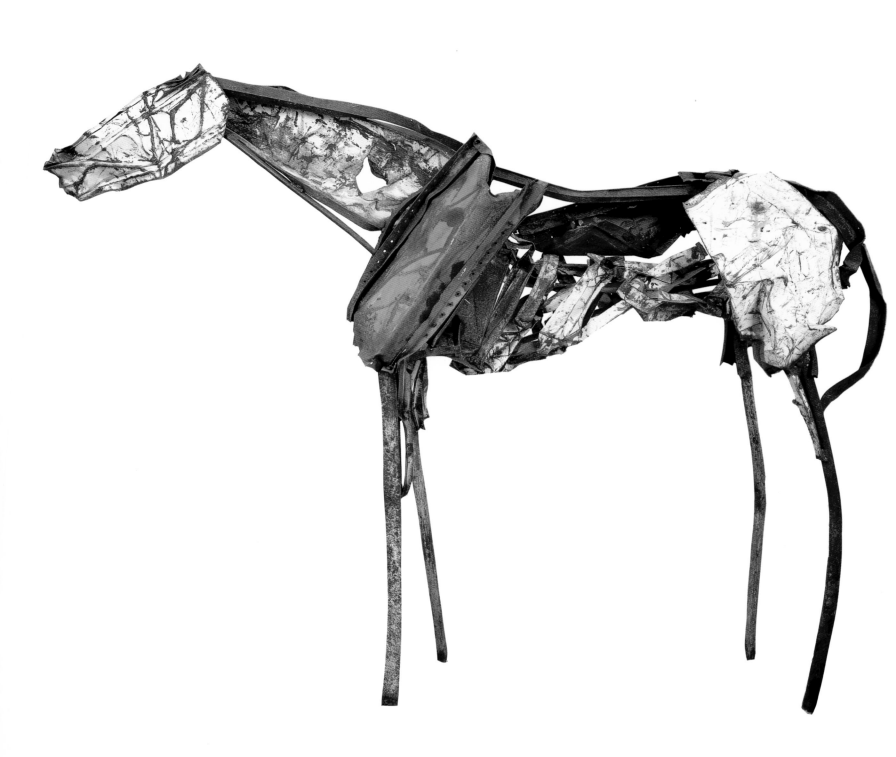

lessness, sacrificed them to instrumental reason, leaving both himself and his noble animal "high and dry, in a sort of despair" — profoundly dispirited.[12] Butterfield's grim horse does not bravely plunge onward but is inert, perversely monumental and empty — so eroded that its hollow insides are visible. It represents the lacerated, compromised spirit of technological man. He is inwardly weary and feeble — narcissistically wounded — for all his relentless instrumental control. Butterfield's horses strip the mask of authority from technology to show the human decay within.

The moment we grasp how completely wounded and victimized Butterfield's horse is, it discloses itself as a profound restatement of the dark side of the traditional symbolic meaning of the horse. We see Butterfield's horse darkly through a technological veil, but its darkness has more than technological meaning. Mary Gedo has pointed out that "later in his career, Picasso often used the gored horse as a symbol for a woman."[13] This is climactically evident in *Guernica*, 1937, where the agony of the hurt horse epitomizes the bull's destruction of the women in the scene. Indeed, Butterfield's *Jerusalem Horse V* bears an uncanny resemblance to the horse in *Guernica*, as well as in several of Picasso's bullfight scenes. Jahns notes "the intimate *juxtaposition of horse and woman* in poetry, proverbial wisdom and sayings . . . The juxtaposition is primeval."[14] This has to do with the fact that the horse, regarded as feminine, connotes "the terrifying and the erotic"; regarded as masculine, it connotes "the noble and divine."[15] Butterfield's horse has a feminist import, representing both the fallen, rotted nobility and divinity of man — ironically destroyed by his own "instrument" of technology — and violated woman, abused by man's technological aggression but still, as the organic color conveys, remaining vivid, even dangerously erotic. Both, in the (mis-)form of the one horse, are ruins of themselves, magnificently morbid. On another level of interpretation, then, Butterfield's horse is a statement of the nightmarish relationship of man and woman.

UNTITLED (ADAN)

1986

steel

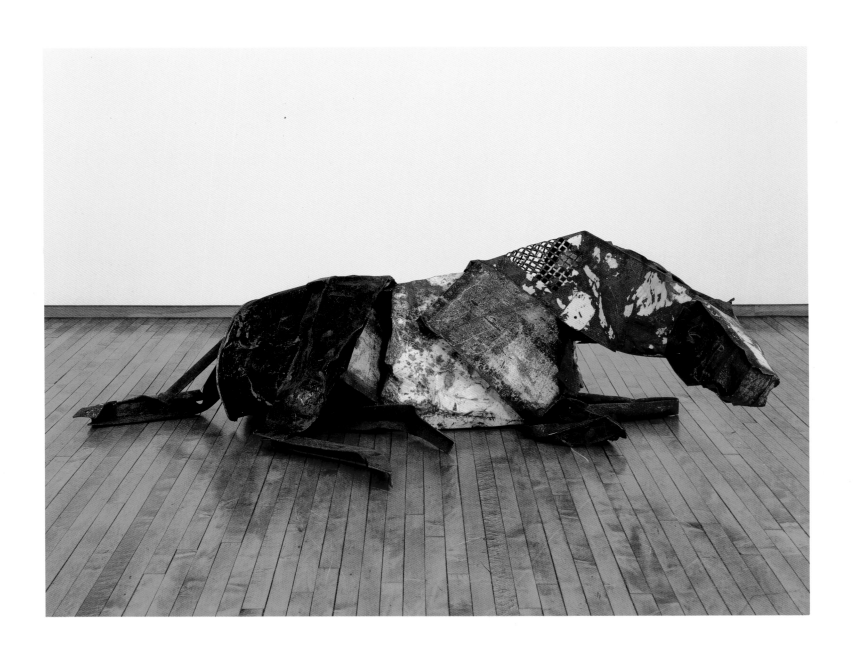

Art historically, Butterfield's sculpture is constructionist. Constructionism can be geometrical or expressivist; the dissociation of sensibility T. S. Eliot remarked affects all modern styles. The full import of Butterfield's extension of the expressivist side of constructionism is best grasped by comparing her horse constructions to the geometrical constructions of another sculptor in steel, Richard Serra. If we regard David Smith as the seminal figure in American steel sculpture—his oeuvre spans the antipodes of expressivism and geometricism, at times eloquently synthesizing them—then we can say that Serra carries Smith's geometricizing tendency to a heroic extreme, and Butterfield carries his expressivist tendency to another, subtler extreme. Butterfield's sculptures are delicate and intricate constructions of odd-sized, erratically shaped pieces of metal; Serra's are uniform constructions of modular units of steel. Like the pioneering constructionist sculptures, Serra's celebrate the technological spirit of modern industrial construction. Indeed, they are full of industrial hubris and bombast—the bravado and arrogance that are the dregs of constructionist utopianism. Clearly such utopianism is obsolete; it has certainly been betrayed by the technological spirit that gave rise to belief in it. One might say that Serra's constructions represent the outer macho shell of constructionism—the obvious muscularity of industrial ambition. In contrast, Butterfield's sculptures represent the inner reality, the "female" vulnerability, that the outer muscularity hides. Her constructionism is truer to our day than Serra's, which harks back, and apotheosizes, an earlier idealism full of illusions about industrialism and thoughtlessly attentive only to its most obvious characteristics. One might say that Butterfield gives us a disillusioned, postindustrial (postmodernist) constructionism, in contrast to Serra's ingeniously naive and outdated industrial modernist constructionism.

Butterfield's sculpture reminds us that it is time for a return to the organic in art, at the least as a reminder that the organic in life—not just

TERRE

1988

steel

MAKUA

1990

cast bronze

nature, but the inward sense of being organically alive—is everywhere
endangered by the technological. But the artist is sufficiently aware of
modern art, and the modern world, to know that this can only be done
dialectically, through acknowledgment of the technological. Technology is
here to stay and cannot be renounced, but must be worked through.
Whether whole and intact like the dignified *Hoover*, 1984 (p. 35), and the
young *Orion*, 1988, or wounded and vulnerable like *John*, 1984, and *Whistle-
jacket*, 1988 (p. 18)—for all his nobility, the former seems to be held together
by the white band(-ages) that constitute most of him, and one can hear the
wind whistle through the metal bones of the latter—Butterfield's horses are
through and through technological constructions. But the pieced together as
well as eccentrically fluid character of the construction—no doubt derived
from and echoing the fluid line of the horse's body—gives the construction
an uncanny organic feel. The horse does not seem like a disguised machine,
as so many modern figural constructions do, but rather a machine in the
process of losing its mechanicalness and becoming a body. Moreover, in
the course of conveying this metamorphosis—also conveyed by the horse's
eloquently equivocal existence as an abstract construction and figural
representation, spontaneously (and reversibly) changing from one to the
other—Butterfield manages to counteract the tendency to make a con-
struction seem as though it was built according to a formula, which has
become conceptually de rigueur today.

Nowhere is Butterfield's revitalization— "organicization"—of construc-
tionism more evident than in an untitled life-size horse, 1977 (p. 45), made of
mud and sticks. The horse has returned to the earth. It is in a more advanced
state of decay than *Jerusalem Horse V* and the *Rosary* horse, although it is not
clear that it is a victim and symbol of the destruction of war, as they are. It
has probably died a natural death and is in the process of returning to nature.
I think these three reclining horses are extraordinary constructions because

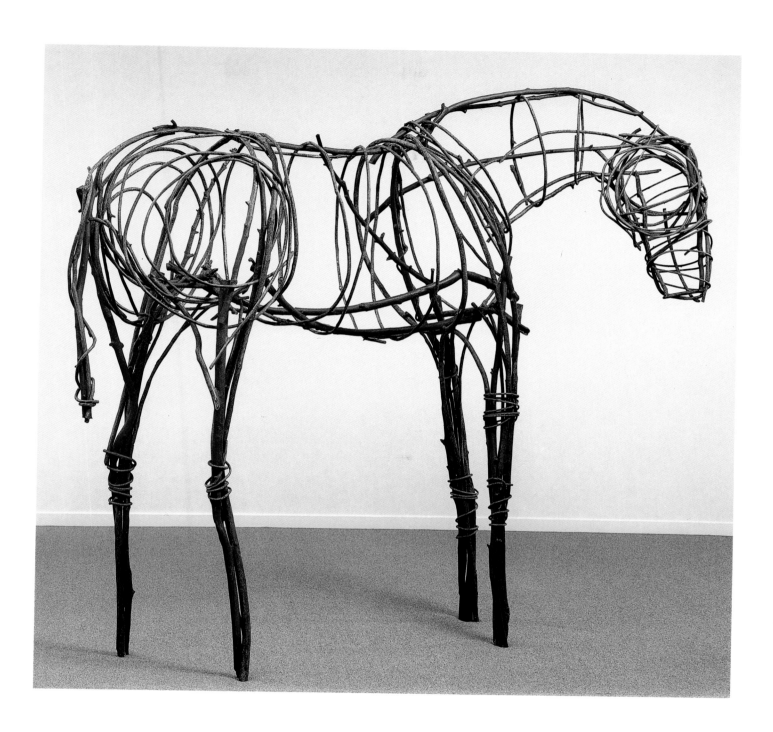

they convey a sense of artificial construction as natural process—a contradiction in terms. As such, they epitomize the dialectical and symbolic complexity implicit in Butterfield's intensity.

NOTES

1. Ernst Jones, *On the Nightmare* (New York: Liveright, 1971), p. 248.

2. Jacques Ellul, *The Technological Society* (New York: Vintage Books, 1964), p. 67.

3. Max Horkheimer, *Critique of Instrumental Reason* (New York: Continuum, 1974), p. vii.

4. Max Horkheimer, "Culture and Civilization," in *Aspects of Sociology* (Boston: Beacon Press, 1973), p. 95.

5. Ellul, p. 135.

6. Kurt H. Wolff, *The Sociology of Georg Simmel* (New York: Free Press Paperbacks, 1964), pp. 402–403.

7. Ellul, p. 375.

8. Ibid., p. 376.

9. Sigmund Freud, *The Ego and the Id* (1923), vol. 19 of *The Standard Edition of the Complete Psychological Works of Sigmund Freud* (London: Hogarth Press and the Institute of Psycho-Analysis, 1961), p. 25.

10. D. H. Lawrence, "St. Mawr," in *The Later D. H. Lawrence* (New York: Knopf, 1952), p. 77.

11. Ibid., p. 79.

12. Ibid., p. 80.

13. Mary Mathews Gedo, *Picasso: Art as Autobiography* (Chicago: University of Chicago Press, 1980), p. 36.

14. Quoted in Jones, p. 248.

15. Ibid.

BIOGRAPHY

Born in 1949 in San Diego, California

Cactus Saddle, 1973

1966-68 San Diego State College

1969 University of California, San Diego

Big Creek Pottery, Santa Cruz, California. Summer Ceramic Workshop.

1970-73 University of California, Davis. B.A., 1972; M.F.A., 1973.

1972 Skowhegan School of Painting and Sculpture, Maine

TEACHING

Leaf Bed (Skowhegan, Maine), 1972

1974-75 University of Wisconsin, Madison. Visiting Lecturer, Sculpture.

1975-77 University of Wisconsin, Madison. Assistant Professor, Sculpture.

1977-79 Montana State University, Bozeman. Visiting Artist.

1979-83 Montana State University, Bozeman. Assistant Professor.

1984- Montana State University, Bozeman. Adjunct Assistant Professor and Graduate Student Consultant.

Burlap, 1973

1972 Skowhegan School of Painting and Sculpture, Maine. Purchase Award for Sculpture and Student Jury Award for Sculpture.

1976 University of Wisconsin, Madison. Grant, Summer Session.

1977 National Endowment for the Arts Individual Artist Fellowship

1980 John Simon Guggenheim Memorial Fellowship

National Endowment for the Arts Individual Artist Fellowship

COMMISSIONS

1975 Circus World Museum, Baraboo, Wisconsin. Commission for sculpture *Percheron*.

1983 Corporate Center, Sacramento, California. Commission for sculpture.

1986 Gladstein & Heesy, Kentucky Derby Festival of Arts, Churchill Downs. Commission for sculpture.

1987 Urban Development Corporation, Boston. Commission for sculpture for Copley Place.

1988 Sculpture Garden, Walker Art Center, Minneapolis

Horse Hooves, 1973

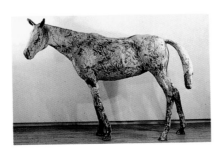

Horse, 1976

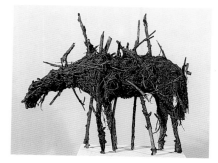

Horse, 1977

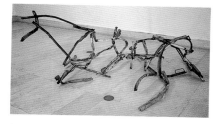

Reclining Horse, 1980

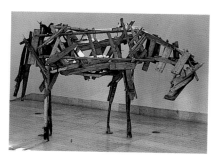

Jacob's Ladder, 1980

1973 Richard L. Nelson Gallery, University of California, Davis, *M.F.A.*
 Exhibition: Deborah Butterfield

1976 Madison Art Center, Wisconsin
 Zolla/Lieberman Gallery, Chicago

1977 Zolla/Lieberman Gallery, Chicago

1978 O. K. Harris Gallery, New York
 Lee Hoffman Gallery, Birmingham, Michigan
 Hansen Fuller Gallery, San Francisco

1979 Zolla/Lieberman Gallery, Chicago
 O. K. Harris Gallery, New York

1980 Open Gallery, Eugene, Oregon

1981 Israel Museum, Jerusalem
 Hansen Fuller Goldeen Gallery, San Francisco
 Museum of Art, Rhode Island School of Design, Providence
 Galerie Zwirner, Cologne
 ARCO Center for the Visual Arts, Los Angeles. Traveled.
 Catalogue.

1982 O. K. Harris Gallery, New York
 Mayor Gallery, London
 Asher/Faure Gallery, Los Angeles
 Dallas Museum of Art

1983 University Art Gallery, New Mexico State University, Las Cruces
 Southeastern Center for Contemporary Art, Winston-Salem,
 North Carolina
 San Antonio Art Institute
 Oakland Museum
 Aspen Center for the Visual Arts, Colorado

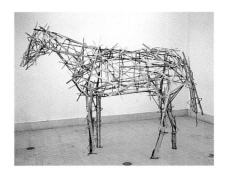

Horse, 1980

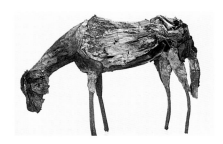

Untitled (#3–85), 1985

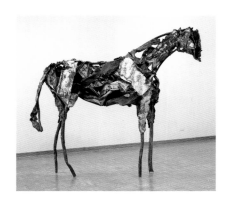

Mokulele, 1986

Chicago Cultural Center

Zolla/Lieberman Gallery, Chicago

1984 Concourse Gallery, Bank of America World Headquarters, San Francisco, *Deborah Butterfield: "Ponder" and "Smokey"*

O. K. Harris Gallery, New York

Galerie Ninety-Nine, Bay Harbour Islands, Florida

Sheppard Fine Art Gallery, University of Nevada, Reno

1985 Gallery of Fine Art, Ohio State University, Columbus, *Still Horses*

Fuller Goldeen Gallery, San Francisco

1986 Contemporary Arts Center, Honolulu. Brochure.

Edward Thorp Gallery, New York, *Deborah Butterfield: Recent Sculpture*

1987 Deweese Contemporary Gallery, Bozeman, Montana

1988 The Faith and Charity in Hope Gallery, Hope, Idaho, *Deborah Butterfield*. Catalogue.

Edward Thorp Gallery, New York, *Deborah Butterfield*

1989 Close Range Gallery, Denver Art Museum, *Deborah Butterfield Sculpture*

Gallery Paule Anglim, San Francisco

Zolla/Lieberman Gallery, Chicago, *Deborah Butterfield*

1990 Edward Thorp Gallery, New York, *Deborah Butterfield: Recent Sculpture*

Zolla/Lieberman Gallery, Chicago, *Deborah Butterfield*

1991 Gallery Paule Anglim, San Francisco, *Deborah Butterfield: Sculpture*

1992 Lowe Art Museum, University of Miami, Coral Gables, Florida, *Horses: The Art of Deborah Butterfield*

1970 Richard L. Nelson Gallery, University of California, Davis, *Twenty-Four-Hour Show*

1971 Richard L. Nelson Gallery, University of California, Davis, *Obscure Artists of Davis*

Shasta College, Redding, California, *Second Annual Shasta College Invitational Art Exhibition*

1972 University of California, San Diego, *Ceramics*

Wenger Gallery, San Francisco, *Eight from Davis*

San Francisco Art Institute Galleries, *The Sacramento Valley*

San Francisco State College, *A Deep Source of Trouble*

Artists' Contemporary Gallery, Sacramento, California, *Sculpture*

American Crafts Council Gallery, New York, *First Southwest Region Exhibition*

1973 Fine Arts Gallery, San Diego, *Media Survey*. Catalogue.

Pan Gallery, Chico, California, *The Great Variety of Northern California Art*

Artists' Contemporary Gallery, Sacramento, California

Oakland Museum, *Statements*. Catalogue.

1974 University Art Museum, University of California, Berkeley, *Two Sculptors: Deborah Butterfield and Rudy Serra*

1976 Krannert Art Museum, Champaign, Illinois, *Paintings and Sculptures by Midwest Faculty Artists*. Traveled. Catalogue.

1977 Art Institute of Chicago, *Seventy-sixth Exhibition of Chicago and Vicinity*. Catalogue.

University of Montana, Missoula, *Drawings from Montana*

John Michael Kohler Arts Center, Sheboygan, Wisconsin, *Beauty of the Beast*

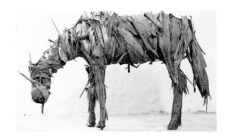

Horse, 1978

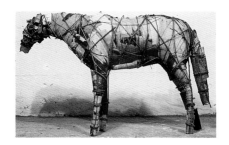

Ruffian, 1978

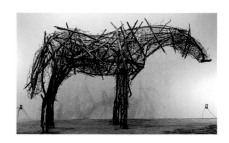

Horse, 1979

1978 Dayton Art Institute, *Paper*. Catalogue.

University of Montana, Missoula, *Montana Sculpture*

Katonah Gallery, Katonah, New York, *Removed Realities: New Sculpture*

Whitney Museum Downtown Center, New York, *The Presence of Nature*

1979 Whitney Museum of American Art, New York, *1979 Whitney Biennial*. Catalogue.

Whitney Museum of American Art, New York, *The Decade in Review: Selections from the 1970s*

Albright-Knox Art Gallery, Buffalo, *Eight Sculptors*. Catalogue.

1980 Queens Museum, Flushing, New York, *Clay Attitudes: Recent Works by 15 Americans*

Indianapolis Museum of Art, *Painting and Sculpture Today 1980*. Catalogue.

Fendrick Gallery, Washington, D.C., *Couples*

Yellowstone Art Center, Billings, Montana, *Montana Current/Ideas*. Catalogue.

Carnegie-Mellon University, Pittsburgh, *3-D Invitational*

Dayton Art Institute, *Woodworks One: New American Sculpture*

1981 Renwick Gallery, Smithsonian Institution, Washington, D.C., *The Animal Image: Contemporary Objects and the Beast*

Miami University Art Museum, Oxford, Ohio, *Works from the Collection of the Whitney Museum: A Seventies Selection*. Catalogue.

Sydney and Frances Lewis Foundation, *Late Twentieth Century Art*. Traveled. Catalogue.

Institute of Contemporary Art, Virginia Museum of Fine Arts, Richmond, *A New Bestiary: Animal Imagery in Contemporary Art*

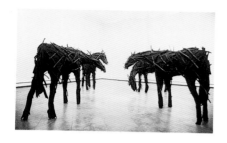

Installation at Albright-Knox Art Gallery, Buffalo, New York, 1979, *Eight Sculptors*

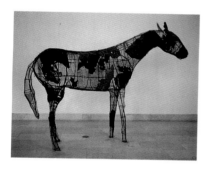

Horse, 1980

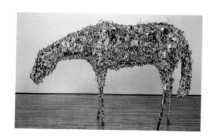

Horse, 1982

Nassau County Museum of Art, Roslyn Harbor, New York, *Animals in American Art, 1880s–1980s*

1982 Palm Springs Desert Museum, California, *The West As Art*

Alberta College of Art Gallery, Calgary, *1st Annual Wild West Show*. Catalogue.

Oakland Museum, *100 Years of California Sculpture*. Catalogue.

Missoula Museum of the Arts, Montana, *Montana Women Artists and the Environment*

Philadelphia Art Alliance, *S/300 Sculpture Tricentennial*

Richard L. Nelson Gallery, University of California, Davis, *Sculptors at U.C. Davis: Past and Present*. Catalogue.

Fresno Arts Center, California, *Forgotten Dimension . . . A Survey of Small Sculpture in California Now*. Traveled. Catalogue.

1983 Freidus Gallery, New York, *The Horse Show*

Herbert H. Lehman College, City University of New York, Bronx, *Fauna, The Animal Ally*

Custer County Art Center, Miles City, Montana, *Contemporary Sculpture in Montana*

Mayor Gallery, London, *Sculpture Then and Now*. Catalogue.

Miami University Art Museum, Oxford, Ohio, *Living with Art Two: The Walter and Dawn Netsch Collection*

Security Pacific Plaza, Los Angeles, *A Midsummer Night's Dream*

1984 Sidney Janis Gallery, New York, *A Celebration of American Women Artists, Part II: The Recent Generation*. Catalogue.

Santa Barbara Museum of Art, California, *Art of the States: Works from a Santa Barbara Collection*. Catalogue.

Hunterdon Art Center, Clinton, New Jersey, *Celebration of the Horse*. Catalogue.

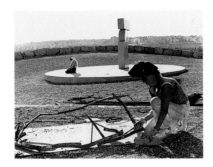

Deborah Butterfield, Israel Museum, 1980

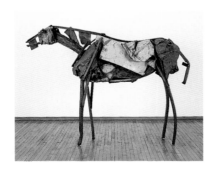

Eclipse, 1986

Toledo Museum of Art, *Citywide Contemporary Sculpture Exhibition*. Catalogue.

Concourse Gallery, Bank of America World Headquarters, San Francisco, *Highlights: Selections from the BankAmerica Corporation Art Collection*

Seattle Art Museum, *American Sculpture: Three Decades*. Brochure.

Matthews Hamilton Gallery, Philadelphia, *Naturlich*

1985 Fuller Goldeen Gallery, San Francisco, *Stars*

Des Moines Art Center, *Iowa Collects*. Catalogue.

Edward Thorp Gallery, New York

Contemporary Arts Center, Cincinnati, *Body and Soul: Aspects of Recent Figurative Sculpture*. Traveled. Catalogue.

Nicola Jacobs Gallery, London, *The Horse in 20th Century Art*

Chicago Sculpture International, State Street Mall, *Mile 4*. Catalogue.

Birmingham Museum of Art, Alabama, *Deborah Butterfield and John Buck*

Edward Thorp Gallery, New York

University Art Gallery, California State University, Chico, *Couples: Party of Two*

Bernice Steinbaum Gallery, New York, *Adornments*. Traveled. Catalogue.

1986 Colorado Springs Fine Arts Center, *The New West*. Catalogue.

Brooklyn Museum, *Third Western States Exhibition*. Traveled. Catalogue.

Concourse Gallery, Bank of America World Headquarters, San Francisco, *Couples in Art*

Amnesty International USA, Santa Fe, New Mexico, *25th Anniversary Art Auction*

Pittsburgh Center for the Arts, *Butterfield/Buck: A Collaboration*. Traveled. Catalogue.

1987 Museum of Art, Rhode Island School of Design, Providence, *The Call of the Wild: Animal Themes in Contemporary Art*. Brochure.

Rena Bransten Gallery, San Francisco, *The Bay Area Collects: A Focus on Sculpture*

Contemporary Arts Center, Cincinnati, *Standing Ground: Sculpture by American Women*. Catalogue.

Whitney Museum at Philip Morris, Sculpture Court, New York

New Museum of Contemporary Art, New York, *The New Museum Tenth Anniversary Benefit Auction 1987*

Sheppard Fine Art Gallery, University of Nevada, Reno, *Thirty from 25*

Zolla/Lieberman Gallery, Chicago, *Outstanding Works by Gallery Artists*

Edward Thorp Gallery, New York

BMW Gallery, New York, *The Artful Traveller*

Gallery Paule Anglim and Janet Steinberg Gallery, San Francisco, *One Exhibition/Two Galleries*

Art Gallery, California State University, Fullerton, *Animals*

Edward Thorp Gallery, New York

Port of History Museum, Philadelphia, *National Sculpture Society Celebrates the Figure: American Figurative Sculpture 1787–1987*. Catalogue.

Philbrook Museum of Art, Tulsa, *The Eloquent Object*. Traveled. Catalogue.

Federal Reserve Board Building, Washington, D.C., *Artists Who Teach: Faculties from the Member Institutions of the National Association of State Universities and Land-Grant Colleges*. Catalogue.

Madison Art Center, Wisconsin, *Sculpture from the Permanent Collection*

Zolla/Lieberman Gallery, Chicago, *New Glory in Sculpture: Recent Work by Gallery Artists*

1988 James Corcoran Gallery, Santa Monica, California, *Lost and Found in California: Four Decades of Assemblage Art*. Catalogue.

Pence Gallery, Santa Monica, California, *Form & Idea*

Whitney Museum of American Art, New York, *Sculpture since the Sixties from the Permanent Collection of the Whitney Museum of American Art*. Catalogue.

Austen D. Warburton Gallery, Triton Museum of Art, Santa Clara, California, *Twelve Artists*. Catalogue.

Missoula Museum of the Arts, Montana, *A Sense of Place: Contemporary Sculpture in Montana*. Catalogue.

Cheney Cowles Museum, Spokane, *Editions: East and West*. Catalogue.

Fuller Gross Gallery, San Francisco, *Contra Costa Contemporary Collections*. Catalogue.

Carl Schlosberg Fine Arts, Sherman Oaks, California, *Sculpture: Works in Bronze*. Catalogue.

1989 University Art Gallery, San Diego State University, *SDSU Choice: Alumni Invitational*

Cincinnati Art Museum, *Making Their Mark: Women Artists Move into the Mainstream, 1970–1985*. Traveled.

Allied Arts Council of Yakima Valley, Weekend Workshops, Yakima, Washington, *Where the Arts and People Meet*

San Francisco Museum of Modern Art, *Montana*

Ted Waddell's Studio, Ryegate, Montana, *Montana '89: Our Place and Time*

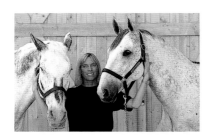

Deborah Butterfield, Bozeman, Montana, 1991

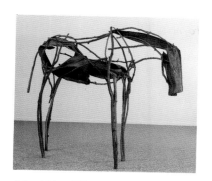

Palapala'aina, 1990

Anne Reed Gallery, Ketchum, Idaho, *Sculpture: Visions Transformed*

Custer County Art Center, Miles City, Montana, *Women's Work: The Montana Women's Centennial Art Survey Exhibition 1889–1989.* Traveled. Catalogue.

Elizabeth Leach Gallery, Portland, Oregon, *Deborah Butterfield, Stuart Lehrman, Italo Scanga*

Cheney Cowles Museum, Spokane, *Masters of the Inland Northwest.* Catalogue.

Madison Art Center, Wisconsin, *Coming of Age: Twenty-One Years of Collecting by the Madison Art Center*

1990 Stones Gallery, Lihue, Kauai, Hawaii, *Visions of the Volcano*

Kentucky Derby Museum, Louisville, *Horse Fresh 16.* Catalogue.

Natsoulas/Novelozo Gallery, Sacramento, California, *All Creatures Great and Small*

North Dakota Museum of Art, Grand Forks, *Nature's Materials*

Bernice Steinbaum Gallery, New York, *The New West*

1991 Boulder Art Center, Colorado, *Big Sky/Bold Wind*

John Natsoulas Gallery, Davis, California, *Thirty Years of TB-9: A Tribute to Robert Arneson.* Catalogue.

Virginia Museum of Fine Arts, Richmond, *Contemporary Sculpture: Perspectives on the Permanent Collection*

Muckenthaler Cultural Center, Fullerton, California, *Sculptural Perspectives for the Nineties*

The Contemporary Museum, Honolulu, *Thirty Years of the Honolulu Advertiser Gallery, 1961–1991*

Art Institute of Chicago

Atlantic Richfield Company, Los Angeles

Columbus Museum of Art, Ohio

Dallas Museum of Art

Hirshhorn Museum and Sculpture Garden, Smithsonian Institution,
 Washington, D.C.

Institute of Contemporary Art, Virginia Museum of Fine Arts, Richmond

Israel Museum, Jerusalem

J. B. Speed Art Museum, Louisville

Lowe Art Museum, University of Miami, Coral Gables

Metropolitan Museum of Art, New York

Milwaukee Art Museum

Museum of Contemporary Art, Chicago

Museum of Contemporary Art, Los Angeles

Oakland Museum

Principal Financial Group, Des Moines

San Francisco Museum of Modern Art

Walker Art Center, Minneapolis

Whitney Museum of American Art, New York

Yellowstone Art Center, Billings, Montana

LIST OF ILLUSTRATIONS

Dimensions are in inches; height precedes width precedes depth. "Small scale" indicates a less-than-lifesize sculpture. If no credit line is given, the present collection is unknown.

27

UNTITLED (HORSE)

1981

paper, sticks, wire; 102 × 168 × 36

J. B. Speed Art Museum, Louisville,

gift of Mr. and Mrs. Henry Heuser, Sr.

28

HAN HORSE

1985

steel, copper, wire, slate;

25 1/2 × 39 × 9 1/2

Private collection

31

ATIYAH

1986

steel; 74 × 115 × 35

Collection of Dr. Jerry Sherman

32

ATIYAH

1986 (detail)

35

HOOVER

1984

steel, wood; 87 1/2 × 100 × 35

Collection of Anne and Martin Z.

Margulies, Miami

36

UNTITLED (HOOVER)

1986

steel; 84 × 96 × 52

Des Moines Art Center, gift of the

Principal Financial Group, 1987.1

39

**JERUSALEM HORSE V
(WAR HORSE)**

1980

steel, wire, metal;

22 3/4 × 138 1/2 × 61

Museum of Contemporary Art,

Chicago, partial gift of Paul and

Camille Oliver-Hoffmann

40

ROSARY

1981

wood, sheet metal, brick dust;

32 × 100 × 58

Walker Art Center, Minneapolis,

purchased in memory of Miriam

Swenson by her friends, 1982, 82.24

41

HORSE

1985

painted and rusted sheet steel, wire,

steel tubing; 82 1/8 × 118 5/8 × 34 1/2

Hirshhorn Museum and Sculpture

Garden, Smithsonian Institution, the

Thomas M. Evans, Jerome L. Green,

Joseph H. Hirshhorn, and Sydney and

Frances Lewis Purchase Fund, 1985

Photo: Lee Stalsworth

42

PALMA

1990

steel; 77 × 119 × 26

Courtesy Edward Thorp Gallery,

New York

45

**UNTITLED (DRY FORK
SERIES)**

1977

mud, ground paper, dextrine, grass,

steel, chicken wire; 31 × 132 × 84

Private collection

46

LAPU

1990

cast bronze with patina;

78 × 111 × 34

Collection of Shelia M. Davis-Lawrence

and M. Larry Lawrence

LAKA

1990

cast bronze with patina;

76 × 94 × 31

Private collection, courtesy Zolla/

Lieberman Gallery, Chicago

47

VERDE

1990

steel; 79 × 108 × 31

Courtesy Edward Thorp Gallery,

New York

48

REX

1991

steel; 75 × 110 × 24

Lowe Art Museum, University of

Miami

50

FERDINAND

1990

steel; 77 × 116 × 33

Yellowstone Art Center, Billings,

Montana

52

DAZZLE

1990

steel; 80 × 30 × 114

Courtesy Edward Thorp Gallery,

New York

55–56, 59

KOSMO

1986 (details)

steel; 75 3/4 × 108 × 28

Private collection

Photo: © 1988 Dorothy Zeidman

60

BEATRICE

1988

steel; 78 × 108 × 50

Collection of Ellen and Richard Levine

Photo: © 1988 Dorothy Zeidman

63

JUNO

1989

cast bronze with patina;

81 × 95 × 75

Collection of John Pappajohn,

Des Moines

64
MALUHIA
1986
steel; 75 1/2 × 117 × 26
Collection of the artist

66
MALUHIA
1986 (detail)

69
JOSEPH
1988

70
UNTITLED (ADAN)
1986
steel; 77 × 104 × 25
New Jersey State Museum, purchase,
FA1988.20

72
TERRE
1988
steel; 28 3/4 × 100 × 52
Brooklyn Museum, purchased with
funds given by Werner H. Kramarsky,
Henry Welt, Harry Kahn, and the A.
Augustus Healy Fund, 88.166

75
MAKUA
1990
cast bronze; 82 1/2 × 98 1/2 × 25 1/2
Collection of Ken and Judy Siebel

77
CACTUS SADDLE
1973
ceramic; lifesize
destroyed

**LEAF BED
(SKOWHEGAN,
MAINE)**
1972
mixed media; lifesize
destroyed

78
BURLAP
1973
plaster, steel, chicken wire, burlap, oil
paint; lifesize
Collection of the artist; on display at
the John Michael Kohler Arts Center,
Sheboygan, Wisconsin

HORSE HOOVES
1973
clay
Collection of the artist

HORSE
1976
mud, paper, steel; lifesize

79
HORSE
1977
mud, sticks, steel; small scale

RECLINING HORSE
1980
mixed media, steel; lifesize

JACOB'S LADDER
1980
wood, steel; lifesize

80
HORSE
1980
wood, steel; lifesize
Collection of Barry Berkus

UNTITLED (#3–85)
1985
steel, sheet metal; 72 × 99 × 36

MOKULELE
1986
metal, wood; 82 × 97 × 28
Collection of Laila and Thurston
Twigg-Smith

82
HORSE
1978
copper wire, eucalyptus bark, steel;
small scale
Collection of Andrew and Betsy
Rosenfield

RUFFIAN
1978
birch bark, willow, steel; small scale
Collection of Walter and Dawn
Clark Netsch

HORSE
1979
wire, wood, steel; lifesize
Private collection

83
HORSE
1980
wood, steel; lifesize

HORSE
1982
cast aluminum, steel;
72 × 108 × 30

84
ECLIPSE
1986
steel; 80 × 110 × 24
Private collection

87
PALAPALA'AINA,
1990
cast bronze; 79 1/2 × 104 × 34
Courtesy Gallery Paule Anglim,
San Francisco

BIBLIOGRAPHY

1972

Frankenstein, Alfred. "The Grotesque
and Fantastic." *San Francisco
Chronicle*, March 8, 1972.

1973

Media Survey. Exh. cat. San Diego: Fine
Arts Gallery, 1973.
Statements. Exh. cat. Oakland: Oakland
Museum, 1973.

1974

Albright, Thomas. "Unique Balance
of Realism, Art." *San Francisco
Chronicle*, June 15, 1974, p. 35.

1975

"Percheron Statue." *Western Horseman*,
September 1975, pp. 128–29.

1976

Artner, Alan G. "Butterfield's Horses
Surface Sensationally." *Chicago Trib-
une*, August 27, 1976, sec. 3, p. 8.
"Deborah Butterfield, Zolla/Lieber-
man Gallery." *Artforum*, December
1976, pp. 76–77.
Feely, Abby. "Horse Sculpture Show
to Open Friday." *Capital Times*
(Madison, Wis.), May 3, 1976, p. 26.
Hanson, Henry. "Modern Sculptress
Makes Horses for the Living
Room." *Chicago Tribune*, August
1976.
Haydon, Harold. "Image and Allegory."
Chicago Sun-Times, July 25, 1976.
Morrison, C. L. "Reviews, Chicago:
Deborah Butterfield, Zolla/Lieber-
man." *Artforum*, vol. 15, no. 4
(December 1976), pp. 76–77.
*Paintings and Sculptures by Midwest Faculty
Artists*. Exh. cat. Champaign, Ill.:
Krannert Art Museum, 1976.
Schulze, Franz. "The Chicago Move-
ment: It's Moving Up." *Chicago
Daily News*, August 21–22, 1976,
Panorama section, p. 11.

1977

"Local Horse Heads for Norway." *Near
North News* (Chicago), July 23, 1977,
p. 1.
Paper. Exh. cat. Dayton: Dayton Art
Institute, 1978.
Schwabsky, Barry. "Deborah Butter-
field." *New Art Examiner*, November
1977.
*Seventy-sixth Exhibition of Chicago and
Vicinity*. Exh. cat. Chicago: Art
Institute of Chicago, 1977.
Spector, Buzz. "Reviews: Deborah But-
terfield, Zolla/Lieberman." *New Art
Examiner*, November 1977.

1978

Dunham, Judith L. "An Unusual Look
at Nature." *Artweek*, November 11,
1978.
Frankenstein, Alfred. "Artist Changing
with the Century." *San Francisco
Chronicle*, October 21, 1978.
Lieberman, Louis. "Butterfield at O. K.
Harris." *New York Arts Journal*, Feb-
ruary 16, 1978.
Sanger, Elizabeth. "If Your Taste in Art
Runs to the Bizarre, O. K. Harris Is
OK." *Wall Street Journal*, August 18,
1978.

1979

Artner, Alan G. "Sculptor Butterfield
Plunges Deeper into a Substantial
Body of Work." *Chicago Tribune*,
May 18, 1979.
Beatty, Frances. "Whitney Winter
Biennial." *Art/World*, vol. 3, no. 6
(February 16/March 16, 1979), pp.
1, 12.
Chicago Tribune, April 28, 1979, sec. 1B,
pp. 1–2.
"Deborah Butterfield." *Craft Range*
(Denver), vol. 10, no. 6 (November/
December 1979), p. 18.
"Deborah Butterfield (OK Harris)."
Soho News, November 15, 1979.

Edelman, Sharon. "Sculpture Show Weaves Art and Architecture." *Buffalo Evening News*, March 23, 1979.

Haydon, Harold. "Waddell Sculptures Capture Natural Beauty in Bronze." *Chicago Sun-Times*, June 8, 1979, sec. 2, pp. 12, 18.

Huntington, Richard. "Albright Sculpture Exhibit a Treat." *Courier-Express* (Buffalo), April 1, 1979.

Kramer, Hilton. "Art: Variety of Styles at Whitney Biennial." *New York Times*, February 16, 1979, p. C17.

Larson, Kay. "Behold a Pale Horse (or Two)." *Village Voice*, November 26, 1979, p. 100.

Morrison, C. L. "Art and 'The System.'" *Format* (St. Charles, Ill.), vol. 1, no. 8 (April 1979), pp. 15–16.

————. "Reviews, Chicago: Deborah Butterfield, Zolla/Lieberman." *Artforum*, vol. 18, no. 2 (October 1979), pp. 68–70.

1979 Biennial Exhibition. Exh. cat. New York: Whitney Museum of American Art, 1979.

"Reviews." *Burlington Magazine*, April 1979, pp. 273, 275.

Saunders, Wade. "Art, Inc.: The Whitney's 1979 Biennial." *Art in America*, May/June 1979, pp. 96–99.

Schultz, Douglas. *Eight Sculptors*. Exh. cat. Buffalo: Albright-Knox Art Gallery, 1979.

Schulze, Franz. "Critic's Choice: Art." *Chicago Sun-Times*, June 17, 1979, p. 10.

"Sculpture: New Directions." *Courier-Express* (Buffalo), March 11, 1979, p. 14.

Whelan, Richard. "Discerning Trends at the Whitney." *Artnews*, April 1979.

1980

Berman, A. "A Decade of Progress, but Could a Female Chardin Make a Living?" *Artnews*, vol. 79, no. 8 (October 1980), pp. 73–79.

"Deborah Butterfield." *Artnews*, vol. 79, no. 3 (March 1980), p. 190.

Montana Current/Ideas. Exh. cat. Billings, Mont.: Yellowstone Art Center, 1980.

Nadelman, Cynthia. "Reviews: Deborah Butterfield." *Artnews*, March 1980, p. 190.

Ronnen, Meir. "Butterfield's Horses." *Jerusalem Post*, November 7, 1980, Magazine section, p. N.

Walsh, Mike E. "Deborah Butterfield: Toward Abstraction." *Artweek*, March 22, 1980, p. 12.

Yessin, Robert A., ed. *Painting and Sculpture Today, 1980*. Exh. cat. Indianapolis: Indianapolis Museum of Art, 1980.

1981

Brandt, Frederick R., and Susan L. Butler. *Late Twentieth Century Art from the Sydney and Frances Lewis Foundation*. Exh. cat. Richmond: Sydney and Frances Lewis Foundation, 1981.

Deborah Butterfield. Los Angeles: ARCO Center for the Visual Arts, 1981.

Deborah Butterfield: Jerusalem Horses. Jerusalem: Israel Museum, 1981.

Dunham, Judith L. "Figural Abstractions and Equine Miniatures: Stephen de Staebler and Deborah Butterfield." *Artweek*, vol. 12, no. 7 (February 21, 1981), pp. 5–6.

Jarden, Richard. *Deborah Butterfield*. Interview. Providence: Rhode Island School of Design, 1981.

Kelley, Jeff. "Explicit Horses: Deborah Butterfield." *Artweek*, vol. 12, no. 43 (December 19, 1981), p. 16.

Muchnic, Suzanne. "Scrap Horses from a Montana Pasture." *Los Angeles Times*, November 24, 1981, sec. 4, p. 1.

Robins, Corinne. *The Pluralist Era: American Art 1968–1981*. New York: Harper & Row, 1981.

Sozanski, Edward J. "Butterfield Breathes Life into Branches and Earth." *Providence Journal Bulletin*, February 27, 1981, Weekend section.

Works from the Collection of the Whitney Museum: A Seventies Selection. Oxford, Ohio: Miami University Art Museum, 1981.

1982

Addington, Fran. "Artist Tries to Explore Disturbing Subjects." *Minneapolis Tribune*, July 11, 1982.

Bolomey, Roger. *Forgotten Dimension . . . A Survey of Small Sculpture in California Now*. Exh. cat. Fresno, Calif.: Fresno Art Center, 1982.

Brandenburg, John. "Metal Horse Exhibit Has Magic of Its Own." *Sunday Oklahoman*, January 24, 1982, p. 14.

Clothier, Peter. "Deborah Butterfield at ARCO Center." *Art in America*, vol. 70, no. 3 (March 1982), p. 155.

Crowe, Ann Glenn. "Deborah Butterfield." *Artspace*, fall 1982, pp. 13–15.

1st Annual Wild West Show. Exh. cat. Calgary: Alberta College of Art Gallery, 1982.

Grossman, Mary Ann. "Butterfield's Horses Are a Different Breed." *St. Paul Pioneer Press*, July 8, 1982, p. B5.

Heartney, Eleanor. "Horses of a Different Color." *Twin Cities Reader* (Minneapolis-St. Paul), July 15, 1982, p. 19.

"Horse Sculpture Shown." *Stillwater NewsPress* (Stillwater, Okla.), January 31, 1982, p. D9.

Kendall, Sue Ann. "Her Sculpted Horses Show Human Despair." *Seattle Times*, September 11, 1982, p. B8.

Kent, Sarah. *Time Out* (London). Review. February 19, 1982.

King, Mary. "Sculptures on 4 Legs." *St. Louis Post-Dispatch*, March 18, 1982, pp. H1, H4.

Kutner, Janet. "Scrap-Metal Stallions Ride the Range with Pride." *Dallas Morning News*, November 2, 1982, pp. C1, C7.

McCloud, Mac. "About Sculpture and Horses: Deborah Butterfield." *Artweek*, vol. 13, no. 32 (October 2, 1982), p. 5.

Marvel, Bill. "Sculpture with the Soul of a Horse." *Dallas Times Herald*, November 3, 1982, pp. F1, F8.

Muchnic, Suzanne. "Giving Life to Metal Horses." *Los Angeles Times*, September 17, 1982, Calendar section, p. 1.

100 Years of California Sculpture. Exh. cat. Oakland: Oakland Museum, 1982.

Rose, Barbara. "Talking About Art." *Vogue*, August 1982, p. 120.

Rubey, Dan. "Women's Show Strong, Paradoxical." *Missoulian*, September 18, 1982, p. A1.

Schmidt, Carol. "Horse Art: An 'Endless Fascination.'" *Bozeman Daily Chronicle*, September 10, 1982, pp. A8–9.

Tallmer, Jerry. "Steeds in Steel and Mud." *New York Post*, April 10, 1982, p. 10.

Tousley, Nancy. "Wild West Show Mixes Humor, Vitality." *Calgary Herald*, June 26, 1982.

Wilson, William. "Sculpture: California Dreaming." *Los Angeles Times*, August 29, 1982, Calendar section, p. 82.

Winegar, Karin. "Sculptor's Horses are Multi-Level Metaphor." *Minneapolis Star and Tribune*, July 2, 1982, p. B3.

1983

Albright, Thomas. "A Sculptor with Horse Sense." *San Francisco Chronicle*, March 23, 1983, p. 56.

Artner, Alan G. "New Emotion Rides on Butterfield Horse Sculptures." *Chicago Tribune*, May 27, 1983, sec. 3, p. 9.

Coffelt, Beth. "They Cast Horses, Don't They?" *Museums of California* (Oakland), vol. 6, no. 5 (March/April 1983), pp. 16–17.

Deborah Butterfield. Exh. cat. Winston-Salem, N.C.: Southeastern Center for Contemporary Art, 1983.

"Deborah Butterfield Visiting Artist at San Antonio Art Institute." *Artists Alliance Review*, February 1983, p. 9.

Fox, Janet. "A Lifelong Love for Horses and Art." *Sentinel* (Winston-Salem, N.C.), February 22, 1983, pp. 13–14.

Gedo, Mary Mathews. "Deborah Butterfield." *Arts Magazine*, vol. 58, no. 3 (November 1983), p. 9.

Guenther, Bruce. *Fifty Northwest Artists*. Photographs by Marsha Burns. San Francisco: Chronicle Books, 1983.

Hansley, Lee. "'Specific Energy': The Butterfield Exhibition at SECCA." *Crescent Observer* (Greensboro, N.C.), April 1, 1983, p. 5.

Heller, Faith. "Creatures with a Mystical and Animistic Grace." *Winston-Salem Journal*, March 27, 1983.

Sculpture: Then and Now. Exh. cat. London: Mayor Gallery, 1983.

Shown, John. "Artist Digs S.A. Junk." *Sunday Express-News* (San Antonio), March 20, 1983, pp. B1, B4.

Simmons, Chuck. "Begging the Question." *Artweek*, vol. 14, no. 41 (December 3, 1983), p. 6.

Stevens, Mark. "Art under the Big Sky." *Newsweek*, October 31, 1983, pp. 98–100.

Tully, Judd. "Paper Chase." *Portfolio*, vol. 5, no. 3 (May/June 1983), pp. 78–85.

"Wherefore Art in Our Montana?" *Western Montana Farm & Ranch* (Helena), November 17, 1983, p. 25.

"Women Artists." *Bijutsu Techo* (Tokyo), vol. 35, no. 15 (September 1983), pp. 14–15, 36–37.

1984

Brown, Daniel. "Living with Art Two." *Dialogue*, January/February 1984, p. 35.

A Celebration of American Women Artists, Part II: The Recent Generation. Exh. cat. New York: Sidney Janis Gallery, 1984.

Celebration of the Horse. Exh. cat. Clinton, N.J.: Hunterdon Art Center, 1984.

Citywide Contemporary Sculpture Exhibition. Exh. cat. Toledo: Arts Commission of Greater Toledo, Toledo Museum of Art, and George P. Crosby Gardens, 1984.

Levin, Kim. "May 16–22, An Opinionated Survey." *Village Voice*, May 1984.

McDonald, Robert. *Art of the States*. Exh. cat. Santa Barbara, Calif.: Santa Barbara Museum of Art, 1984.

Ratcliff, Carter. "Collectors' Close-Up" and "The Collectors: California Outlook." *Architectural Digest*, April 1984, pp. 86, 134–41.

Spero, Susan. "Still Horses: Sculpture by Deborah Butterfield." *Dialogue*, January/February 1984. (Reprinted in newsletter of Ohio State University Gallery of Fine Art, 1985.)

1985

Fishman, Nancy, ed. *Mile 4*. Exh. cat. Chicago: Chicago Sculpture International, 1985.

"High Wrangling." *San Francisco Chronicle*, September 28, 1985.

Iowa Collects. Exh. cat. Des Moines: Des Moines Art Center, 1985.

Krantz, Les. *American Artists*. Chicago: Krantz Co., 1985.

Litt, George. "Scraps Create Life-Size Art." *Ohio State Lantern*, February 5, 1985, p. 8.

Lugo, Mark-Elliott. "Equine Artist Powers on Verge of Stardom." *San Diego Tribune*, October 4, 1985, pp. C1, C7.

Morch, Al. "Horsing Around with Art Shows in the City." *San Francisco Examiner*, October 21, 1985, pp. E1, E6.

Mullen, Kathleen. "Horses: An Artist's Metaphorical Self-Portrait." *Business First Magazine* (Columbus), February 25, 1985, p. 22.

Nelson, James R. "Art Happenings: Assemblage, Canvas Give Taste of Current Aesthetic." *Birmingham News*, July 21, 1985, p. F7.

Nusbaum, Elliot. "Striking New Art Center and Powerful New Exhibit." *Des Moines Register*, May 5, 1985, pp. C1, C5.

Perreault, John, and Judy Collischan van Wagner. *Adornments*. Exh. cat. New York: Bernice Steinbaum Gallery, 1985.

Rogers-Lafferty, Sarah. *Body & Soul: Aspects of Recent Figurative Sculpture*. Exh. cat. Cincinnati: Contemporary Arts Center, 1985.

"'Still Horses' Exhibit in OSU Gallery Honors College of Veterinary Medicine Centennial." *Ohio State University Alumni Magazine*, March 1985, p. 28.

Veselenak, Anne. "Horses Display Artist's Love." *Ohio State Lantern*, February 5, 1985, p. 8.

Veterinary Economics, May 1985, p. 6.

1986

Baker, Kenneth. "Potatoes and Timbers and Such." *San Francisco Sunday Examiner & Chronicle*, June 15, 1986, Review section, pp. 10, 13.

Bednarczyk, Susan. "Way out West in Brooklyn." *Artlines*, August 1986, p. 11.

Brenson, Michael. "How the Myths and Violence of the West Inspire Its Artists." *New York Times*, June 15, 1986, p. H38.

————. "Deborah Butterfield." *New York Times*, December 12, 1986, p. C28.

Deborah Butterfield: Hawaiian Horses. Exh. brochure. Honolulu: Contemporary Arts Center, 1986.

Deitch, Sande, and Bruce Guenther. *Butterfield/Buck: A Collaboration*. Exh. cat. Pittsburgh: Pittsburgh Center for the Arts, 1986.

Fischl, Eric, and Jerry Saltz, eds. *Sketchbook with Voices*. New York: Alex van der Marck Editions, 1986.

Johnson, Mark M. "Western States Art." *Arts & Activities*, November 1986, pp. 22–24.

Larson, Kay. "Love or Money." *New York Magazine*, June 23, 1986, pp. 65–66.

McGuigan, Cathleen. "The Soho Syndrome." *Newsweek*, September 22, 1986, p. 80.

Morse, Marcia. "Persuasive Models for an Active Imagination." *Honolulu Star-Bulletin & Advertiser*, March 30, 1986, p. C11.

The New West. Exh. cat. Colorado Springs: Colorado Springs Fine Arts Center, 1986.

Ronck, Ronn. "Horses of Steel for Paniolos." *Honolulu Advertiser*, March 13, 1986, p. B1.

Third Western States Exhibition. Exh. cat. Brooklyn: Brooklyn Museum, 1986.

Tsing Loh, Sandra. "Raw Data, Mute Angels." *Element Magazine* (Los Angeles), summer 1986, pp. 15–17.

Watson-Jones, Virginia. *Contemporary Women Sculptors.* Phoenix: Oryx Press, 1986, pp. 80–81.

Wolff, Theodore F. "Western Art." *Christian Science Monitor*, June 30, 1986.

1987

Bass, Ruth. "Deborah Butterfield." *Artnews*, vol. 86, no. 3 (March 1987), p. 149.

Evans, Ingrid. "Notes from a Nevada History." *Artweek*, vol. 18, no. 19 (May 16, 1987), p. 1.

Goley, Mary Anne. *Artists Who Teach.* Exh. cat. Washington, D.C.: Federal Reserve Board Fine Arts Gallery, 1987.

Henry, Jean, ed. *The National Sculpture Society Celebrates the Figure.* Exh. cat. New York: National Sculpture Society, 1987.

Kazanjian, Dodie, ed. "Portrait of the Artist: Who Supports Him/Her?" *Art Review*, vol. 4, no. 3 (1987).

Krainak, Paul. "Marriage & Collaboration." *Dialogue*, January/February 1987, p. 29.

Kuspit, Donald. "Deborah Butterfield, Edward Thorp Gallery." *Artforum*, vol. 25, no. 7 (March 1987), pp. 122–23.

Leonard, Michael. "News from the North." *Artweek*, vol. 18, no. 28 (August 22, 1987), p. 4.

McConnell, Gordon. *A Montana Collection, 1985–1987.* Exh. cat. Billings, Mont.: Yellowstone Art Center, 1987.

McCormick, Jim. *Thirty from 25.* Exh. cat. Reno, Nev.: University of Nevada, 1987.

Manhart, Marcia, and Tom Manhart. *The Eloquent Object.* Exh. cat. Tulsa: Philbrook Museum of Art, 1987.

Martin, Richard. "A Horse Perceived by Sighted Persons: New Sculptures by Deborah Butterfield." *Arts Magazine*, vol. 61, no. 5 (January 1987), pp. 73–75.

Muchnic, Suzanne. " 'Western States' Shows a Murky View of the State of the Sun Belt." *Los Angeles Times*, December 26, 1987, Calendar section, pp. 1, 7.

Nussbaum, Elliot. "Butterfield & Buck Craft an Intricate 'Autobiography.' " *Des Moines Sunday Register*, June 7, 1987, p. C5.

"Old Masters, New Guard." *Gentleman's Quarterly*, August 1987, p. 173.

Rogers-Lafferty, Sarah. *Standing Ground: Sculpture by American Women.* Exh. cat. Cincinnati: Contemporary Arts Center, 1987.

Rosenfeld, Daniel. *The Call of the Wild: Animal Themes in Contemporary Art.* Exh. brochure. Providence: Museum of Art, Rhode Island School of Design, 1987.

Schwabsky, Barry. "Deborah Butterfield." *Arts Magazine*, vol. 61, no. 6 (February 1987), p. 107.

Westfall, Stephen. "Deborah Butterfield at Edward Thorp." *Art in America*, vol. 75, no. 4 (April 1987), p. 218.

1988

Artists in Schools — Communities. Exh. cat. Helena: Montana Arts Council, 1988.

Berry, Paul, and Robert B. Goodman. *Choices: An Essay on Contemporary Art.* Honolulu: Beyond Words Publishing Co., 1988.

Chastian-Chapman, Tony. "Aspiring to History." *American Craft*, April/May 1988, p. 34.

Friedman, Martin, and Marc Treib. *Minneapolis Sculpture Garden.* Exh. cat. Minneapolis: Walker Art Center, 1988.

McGill, Douglas C. "Art People." *New York Times*, January 8, 1988.

"A Please-Touch Sculpture Garden." *New York Times*, September 4, 1988.

Talley, Charles. "Surveying the Poetic Object." *Artweek*, vol. 19, no. 16 (April 23, 1988), p. 1.

1989

Allison, Sue. "Art, Her Infinite Variety: A Spectacular Exhibition of Female Force." *Life*, June 1989, p. 67.

Andrews, Mea. "Unique Flirtations with Everyday Topics." *Missoulian*, October 7–13, 1989, pp. A1, A5.

Artner, Alan G. "Gallery Reopens Triumphantly with Sculptor." *Chicago Tribune*, November 10, 1989, sec. 7, p. 1.

————. "Top Artists Join AIDS Benefit in S.F." *San Francisco Chronicle*, May 19, 1989.

Baker, Kenneth. "Sculptor Not Just Horsing Around." *San Francisco Chronicle*, March 2, 1989, p. E3.

Bradley, Jeff. "Sculptor Puts Her Heart into Life-Size Metal Horses." *Denver Post*, October 2, 1989, pp. D1, D4.

Brookman, Donna. "Beyond the Equestrian." *Artweek*, February 25, 1989.

"Deborah Butterfield." *Artspace*, vol. 13, no. 2 (May/June 1989), p. 12.

Everingham, Carol J. "Two Bronze Horses Will Graze, Gaze at People in Bruce Park." *Greenwich Times*, August 16, 1989, Arts section, p. B4.

Handy, Ellen. "Edward Thorp Gallery." *Arts Magazine*, January 1989, p. 99.

McConnell, Gordon. *A Montana Collection: 1987–1989.* Exh. cat. Billings, Mont.: Yellowstone Art Center, 1989.

Russell, John. "Cosmopolitan Artworks along Suburban Byways." *New York Times*, August 4, 1989, p. C1.

Tucker, Marcia. "Equestrian Mysteries." *Art in America*, June 1989, pp. 154ff, 203.

"Women Artists at Denver Art Museum." *Art Now — Gallery Guide*, July–August 1989, p. SW11.

1990

Freudenheim, Susan. "Museum of Art OKs 3 Major Buys." *San Diego Tribune*, April 26, 1990, pp. D1, D8.

"Horse of a Different Color." *Chicago Tribune*, February 28, 1990, sec. 2, p. 1.

Of Nature & Nation: Yellowstone Summer of Fire. Exh. cat. Los Angeles: Security Pacific Corporation, 1990.

22nd Annual Art Auction. Exh. cat. Billings, Mont.: Yellowstone Art Center, 1990.

Zimmer, William. "A Sculpture Exhibition That Sounds a Single Note: Horses." *New York Times*, March 11, 1990, p. 28 CN.

1991

Hirsch, Faye. "Deborah Butterfield." *Arts Magazine*, March 1991, p. 77.

Yellin, Deborah. "Deborah Butterfield — Edward Thorp." *Artnews*, April 1991, p. 154.

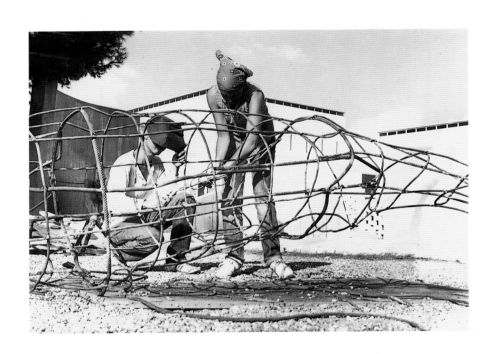